IMAGES
of America

GROVER BEACH

IMAGES
of America

GROVER BEACH

Anita Shower

ARCADIA
PUBLISHING

Published by Arcadia Publishing
Charleston SC, Chicago IL, Portsmouth NH, San Francisco CA

Printed in the United States of America

Library of Congress Catalog Card Number: 2007933024

For all general information contact Arcadia Publishing at:
Telephone 843-853-2070
Fax 843-853-0044
E-mail sales@arcadiapublishing.com
For customer service and orders:
Toll-Free 1-888-313-2665

Visit us on the Internet at www.arcadiapublishing.com

To the residents of this area who began among the eucalyptus trees and shall always be remembered.

CONTENTS

ACKNOWLEDGMENTS

As a citizen of Grover Beach, having arrived when it was known as Grover City, I am pleased to present to all of the city's population a timeline in words, photographs, maps, and memories of what was recorded as the beginning of the area in the late 1880s up to and including the people and events of 1970. With due respect, I included the date of the city's name change and the date the railroad depot became a reality.

Someone always paves the way for a historian who takes the reins where another has left off. I thank Jean Hubbard for her style and years of writing, for saving the stories and columns, and for passing on her cherished gifts. Thank you to Linda Guiton Austin who, with the flick of her wrist, was willing to pull a document from a file and gracefully hand it over. Thank you to Gordon Bennett for encouragement and to Leslie Zabel for taking her personal commitment of integrity and mutual respect to the highest level.

I thank the people who believed in me and urged me to write, especially Vern Ahrendes for giving me the first opportunity to put my thoughts to paper, George J. Moylan for showing me how to create images with words, and to Manferd Shower for understanding the necessity of completing this historical work. Thank you to my mother, Harriett Farina, for passing her clerical and organizational skills onto me. Thank you to Devon Weston, who began this adventure with me and remained an angel of a publisher.

In that Grover Beach is without a central collection area for citizens to donate their photographs, I thank each person who loaned me their images to scan and encouraged me to write the story of this place, which has also been known as the township of Grover, Grover, and Grover City. We, the citizens of this extraordinary city, always knew what we had; it is time to share our history from the all-volunteer fire department to the builders of the youth foundation building, and from Hero's pig farm to the strawberry fields.

—Anita Shower

INTRODUCTION

Grover Beach is a coastal city, one of several in San Luis Obispo County, California. In 1842, the area was claimed by Jose Ortega; he had a Mexican land grant. In 1867, the Ortega Land Grant was claimed by Isaac Sparks; it was 8,838 acres of the South County (of San Luis Obispo County). Sparks named the area El Pizmo Rancho. Twenty years later, Sparks sold half of the acreage to John Michael Price. In April 1887, Price sold 1,149.11 acres of the Pismo rancho to D. W. Grover and his associate, George Gates, for $22,982.20 in gold. They called it the Town of Grover and Huntington Beach. They were banking on the Southern Pacific Rail Road going from where it ended at San Miguel in San Luis Obispo County all the way south past the town of Grover.

Dwight William Grover was a lumberman from Santa Cruz, who was born on November 10, 1852. He purchased the acreage from Price on April 8, 1887. Grover hired a San Francisco–based firm of Carnall-Hopins Company to take care of sales. The land auction took place in August 1887, which drew more than 1,000 people. The promotion was enticing; a souvenir advertisement for Grover City from the Bennett Loomis Archives touted:

> Great Auction Sale—of—Choice RESIDENCE AND BUSINESS LOTS! AT GROVER! The new seaside resort, Pismo Beach, San Luis Obispo County, Cal.,—on—TUESDAY AND WEDNESDAY, AUGUST 2D AND 3D, 1887. At 12 o'clock N, each day.—Also—Villa Tracts of 5 and 10 Acres—Adjoining the—TOWN OF GROVER!

Grand Avenue, being grand, was laid out to stretch from Arroyo Grande to the Pacific's seashore. The areas, roads, and lots were staked on the hills of Grover when that first auction took place. The auctioneer was C. C. Thayer, and he accompanied the contingency from San Francisco to Port San Luis. When they arrived in Arroyo Grande for the auction, the townspeople were out in force. There was local produce for sale, buggies everywhere, people waving, and businessmen. After the barbecue, Thayer began selling the lots. Once a deal was struck, lumber was available for delivery.

In addition to C. C. Thayer, there were four clerks to handle the paperwork. The auction started at noon; by the time the sun set, 133 lots were sold for a total of $15,000. Many of the visitors thought the price was too high; the average cost of a lot was $112.

On August 10, 1887, D. W. Grover and a couple of his friends registered the paperwork for their land endeavor corporation. It was called the Southern Land and Colonization Company of San Luis Obispo, California. The money and shares in the corporation were as follows: D. W. Grover, George Gates, John M. Duke, Samuel Rosener, and J. M. Lesser each paid $100,000 and each received 1,000 shares; and Clarence C. Thayer paid $50,000 for 500 shares. According to the county clerk's office in San Luis Obispo County, the records indicate the purpose of the corporation was "to buy, sell, barter, exchange, on commission or otherwise, or at auction of private sale real estate to buy and loan money on, as and receive mortgages from and colonization land and etc." The capital amount totaled $500,000.

In the 1890s, D. W. Grover set out to make the train station a reality. Grover felt the depot would attract tourists and investors. Unfortunately, the Southern Pacific Rail Road decided to construct the depot in the San Luis Obispo County area known as Oceano, thus crumpling Grover's dream. Grover returned to Santa Cruz, where he is buried.

One

DWIGHT WILLIAM GROVER TO JAMES F. BECKETT

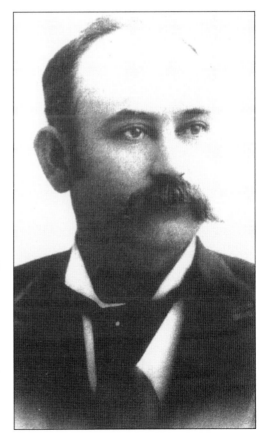

Although the Grover family left Maine in 1848 for California and the promise of gold, the family made its fortune in lumber. Dwight William Grover, pictured with a mustache, was born on November 10, 1853, to James Lyman and Hannah Elsmore Grover. Dwight and his wife, Mary Emma Halstead Grover, set out from the Santa Cruz area for the coastal area of El Pizmo in 1887 when he was 35. He purchased the land now bearing his name and filed papers with San Luis Obispo County in the same year. His tagline was, "Where the tidelands and the rails meet." Grover had high hopes that the railroad would quickly be added onto the end of the line in San Miguel, California, and travel on its way south past his new "Town Site of Grover and Huntington Beach." (Courtesy Mr. and Mrs. Paul Hammock.)

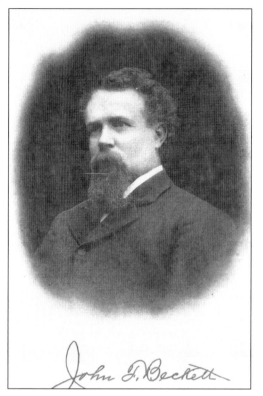

John F. Beckett

Developer John F. Beckett, photographed here in 1900, was from Polk County, Iowa. In 1859, his family moved from Oregon to California, and in 1869, he moved to San Luis Obispo. He taught public school, established the first commercial nursery in the county, and became the county's superintendent of schools. He also held real estate in Arroyo Grande, including Oso Flaco, Chimeneas, Tar Springs, Tally-ho, and the Verde Colonies (One, Two, and Three); the Crown Hill addition; the Corbett tract; and E. W. Steel's re-subdivision of the Corral de Piedra Ranch. Beckett considered purchasing and developing the 1,200 acres of Grover his greatest real estate accomplishment, which he named Beckett Park and the Beckett Place subdivision tract. Beckett named the streets. This last tract was situated near Pismo Beach and ran 3 miles east from the ocean. (Courtesy Mr. and Mrs. Paul Hammock.)

The San Luis Obispo newspaper noted in 1891, "We understand that Mr. Beckett is to have the handling of the Grover property, and that is the secret of the opening of the Avenue (Grand)." John F. Beckett and his son ventured into a business called Beckett and Beckett, and their tag line was "We sell the Earth." The advertisement appeared in the *Weekly Herald* on June 24, 1905. (Courtesy Bennett-Loomis Archives.)

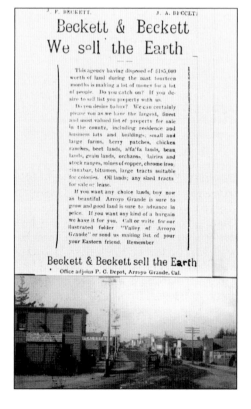

Two

MR. BAGWELL SR.'S DREAM

Horace V. Bagwell came to Grover in 1935. His partner in real estate matters was Harry Culver. Bagwell purchased the Grover land from Harold E. Guiton. Guiton acquired the property by this grant deed pictured; it was a grant deed from B. C. Beckett, who was also known as Bertram C. Beckett, and Laura May Beckett, Bertram's wife, to Harold R. Guiton, a married man. The deed is dated October 6, 1933, and was recorded in the official record's book of San Luis Obispo County on that same date. This deed contained approximately 60.723 acres. Some time later, when Charles Bagwell came to Grover, part of the Guiton family decided to venture into real estate and began working with Charles and his company. (Courtesy Linda Guiton, Austin Archives.)

965

Instrument No.

Order No.

When recorded mail to

Harold Guiton

Oceano, Calif.

RECORDED AT REQUEST OF

Harold E. Guiton

MAR 9 - 1935

AT 57 MIN. PAST 11 O'CLOCK A. M.

IN VOL. 162 OF OFFICIAL RECORDS

PAGE 445 SAN LUIS OBISPO COUNTY,

CALIFORNIA.

W. L. RAMAGE

COUNTY RECORDER

BY *Dorothy Bruce*

DEPUTY RECORDER

TITLE INSURANCE AND TRUST COMPANY
433 South Spring Street, Los Angeles, California

1715 CHESTER AVENUE, BAKERSFIELD
14 EAST CARRILLO STREET, SANTA BARBARA
998 MONTEREY STREET, SAN LUIS OBISPO

UNION TITLE INSURANCE CO.
1028 SECOND STREET, SAN DIEGO

VENTURA ABSTRACT COMPANY
429 MAIN STREET, VENTURA

TULARE COUNTY ABSTRACT CO.
204 WEST MAIN STREET, VISALIA

RIVERSIDE TITLE COMPANY
3940 MAIN STREET, RIVERSIDE

The other grant deed pictured is between B. C. Beckett and Laura May Beckett, husband and wife, granting acreage to Harold E. Guiton of Oceano, California. The deed is for 1,278.23 acres in the town of Grover and, combined with the previous deed, equates to the entire town of Grover, which was 2.23 square miles. The Pismo-Pacific Properties Corporation, Limited previously subdivided a portion of south Grover, according to information dated November 14, 1930. This particular grant deed had exceptions and reservations unto J. A. Beckett, his heirs, and assigns, dealing with an undivided half-interest in all oil, gas, and minerals of all kinds upon said lands, if ever found. The grant deed, dated March 9, 1935, was recorded on this same date in the record's book of San Luis Obispo County. Horace V. Bagwell obtained this deeded property from Guiton and continued to subdivide Grover. Horace named the streets in those subdivisions per Don Ewing, who attended school with Horace's son, Charles. (Courtesy Linda Guiton, Austin Archives.)

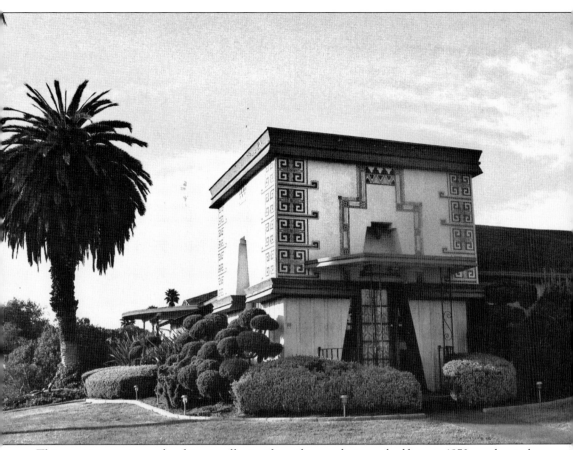

This most interesting and architecturally significant home, photographed here in 1970, was located in the San Luis Obispo County area known as Oceano and was built by William Wise. When they first arrived in the area in 1935, Horace V. Bagwell and his partner, Harry Culver, used the tower area in the home as their real estate office. When the house was originally constructed, it had a fishpond built into the center of the floor in the main area of the house. It had wall sconces that were extraordinary, but unfortunately, all were discarded when the owner (and wife) of Carl's Spanish Seas purchased the property and attached a restaurant to the garage end of the home. The new owners drained the fishpond and cemented over the attraction. The house stands today on the same lot. (Author's collection.)

GROVER CITY DEVELOPMENT CO.

MAILING OFFICE:
128 S. VERMONT AVE., LOS ANGELES 4, CALIF. TEL. FIT. 4519
MAIN OFFICE: GROVER CITY VIA PISMO BEACH, CALIFORNIA
GRAND AVENUE AND ROOSEVELT HIGHWAY ON PROPERTY

GROVER CITY—IDEAL PLACE FOR A HOME

Grover City, located on the great Roosevelt Highway—less than five hours drive from Los Angeles—with the 101 Highway skirting the property on the North, presents today the lowest priced improved ocean view lots and acreage in the State of California. There is only a small amount, comparatively, of desirable Beach property in California remain-

ing for sale to the general public at prices within the reach of the man or woman of moderate means. This property, among the last, and comparable to any of its kind in the world, may be had at astonishingly low prices.

Grover City is a sane, sound, substantial American community, with a highly productive back-country. It has many beautiful gardens, and small ranches where strawberries, boysenberries, artichokes, winter peas, pole peas, lettuce, celery and various kinds of fruits and vegetables are grown, and for which the beautiful Arroyo Grande Valley is noted.

In and around Grover City chicken and turkey raising is a growing and profitable branch of the poultry industry. Chickens and turkeys thrive here, and there are a number of chicken ranches with hundreds of fine, healthy chickens.

After his arrival in 1935, Horace Bagwell began the H. V. Bagwell Company, Inc., also known as the Grover City Development Company. The area began to move forward. This Grover City Development Company brochure reached far and spoke of chicken ranches, turkey farms, and a limit to the number of clams on a daily "dig." The other side of the brochure mentioned that the beach area had a sign posted, stating, "Closed Clam Area" south of Oceano, which "prohibited passage in the interest of conserving the clam population." Bagwell's dream was to sell Grover. Culver was his partner, and the two worked together in building Culver City. Bagwell advertised the area as "the home of the average man." The Grover City Development Company had offices in the tower of the Wise house in Oceano. The office moved in 1962 to relocate to Grover on North Second Street at Grand Avenue. Bagwell passed away in 1958, one year before the city's incorporation. (Courtesy Jean Hubbard.)

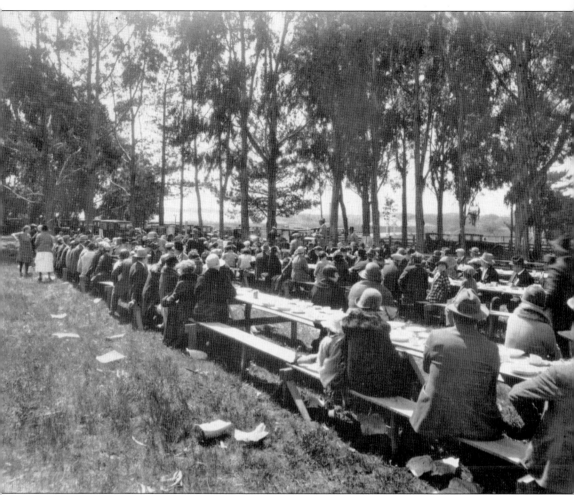

There was a time during Grover's early years when the developer would host a huge picnic on the south side of Grand Avenue near the railroad tracks, as shown in this c. 1935 photograph. There were long picnic tables side by side with a row of Eucalyptus trees on one side of the area. People arrived at the festivities dressed in their best clothes. The developer would give a speech about the greatness of the area, trying to entice people to buy property. This photograph of the area is near the railroad crossing markers at Roosevelt Highway and Grand Avenue. The railroad markers are on white posts without lights. The ladies at the left of the photograph wearing aprons were the servers. (Courtesy Jean Hubbard Archives.)

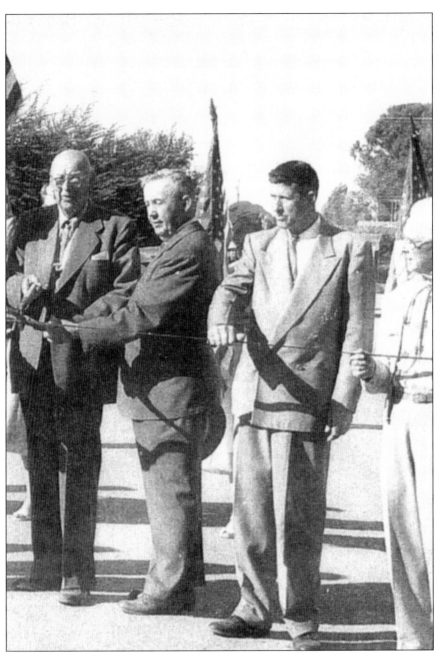

Horace Bagwell, pictured at left in this 1957 photograph during the dedication of Pismo Road, also known as North Fourth Street, was one of the founding members of the Grover City Grange. He strongly believed in the values of the Grange: working together, playing together, and being together. He felt it was the same in rural life as it was in urban life. The Grange strongly promoted community service, and Horace exemplified community service. The Grange Hall was completed in 1956 by a community-minded, all-volunteer committee. It was called the best Grange Hall in all of California. Bagwell also enjoyed fishing and would go with Lloyd Qualls to Lopez Lake on long fishing trips. Lloyd did all the fishing, and Horace did all the sleeping, complete with an umbrella and a fishing pole. (Courtesy Jean Hubbard.)

Three

THE SAN JUAQUIN VALLEY AND GROVER CITY

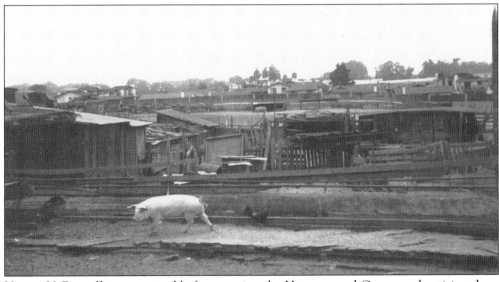

Horace V. Bagwell was responsible for escorting the Heros around Grover and enticing them to buy property. Einar Hero and his wife, Leona, came to Grover in 1944 from the San Joaquin Valley; they were like others who wished to be near the coast. The area was ideal for farming and already had several little cabins on the north side of Grand Avenue. Einar and Leona stayed with Bagwell in his home when they visited to look over property. During subsequent visits, if the house was full of others wishing to purchase land, the Heros would stay in a wigwam cabin in Bagwell's yard. Bagwell took Hero up to north Grover, and Hero purchased two lots. On one he built a cabin to live in, and on the other, he built a cabin to rent out. The cabins were two rooms each. The next visit to view property was of this photographed area, in 1970, on Grover's south side on Farroll Road. (Author's collection.)

During the late 1940s, Einar and Leona Hero purchased this Farroll Road property. Their son, also named Einar, was always proud to say when he moved to Grover, "I could count all the houses on the north side on one hand." By 1970, Betty, the Heros' daughter, had purchased the property across the street from her family's pig farm. Christina Mina had already purchased the property to the west of Betty's property. Einar Hero passed away in 1974, leaving his widow and son to care for the 30-acre parcel. The farm had its share of dogs, cats, 800-pound sows, piglets, wagon wheels, and wooden pallets; it remained a landmark in the area. A fatal farm accident in 1999 claimed son Einar Hero's life. The farm was sold to a firm in its entirety in 1981. Ninety-one homes and a city pocket park named Hero's Park now occupy the land where the farm used to be. (Author's collection.)

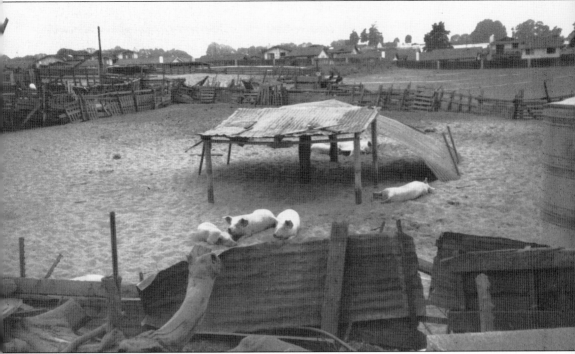

The Grover community and people from the San Joaquin Valley were all familiar with Einar Hero's pig farm, shown here in 1970. The pigs provided entertainment for children and projects for 4-H and FFA youngsters. Adults wanted the pigs for parties and fiestas. It was common for the pig farm in the 1960s and 1970s to house 150 pigs. Some neighbors considered the farm a luxury, comparable to having a vacant lot next door. Those who had complaints were short-lived. The San Joaquin Valley residents, the San Luis Obispo residents, and people from Santa Maria provided the customer base for the pigs. Most who wanted a pig wanted all of it, including the insides. Using the entire pig was a cultural difference, for in Hispanic households the entire animal would be consumed (as well as in Filipino homes), and Einar Hero was happy to oblige. A rooster crowing could always be heard from the farm. In the late 1980s, the city passed a special ordinance that allowed the Hero family to farm "as long as they want to farm." (Author's collection.)

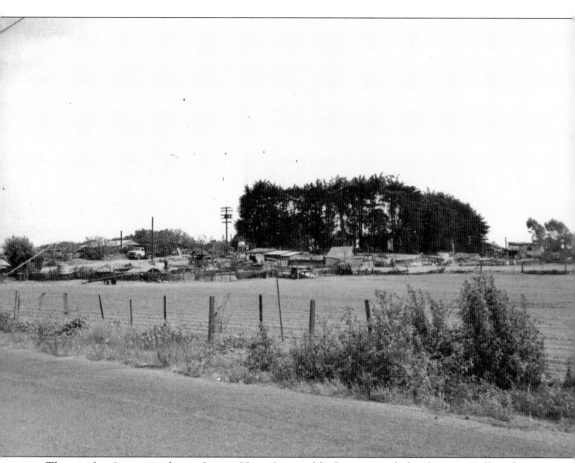

The pig farm's matriarch was Leona Hero. Leona felt Grover needed a Grange Hall and was instrumental in getting the concept off the ground. Ground-breaking was in 1956, with the acre site paid in advance in 1957. Work started quickly with volunteers immediately being signed up. The charter members were Mr. and Mrs. Y. O. Brosseau, Horace V. Bagwell, Pauline Brooks, Charles Dague, Einar and Leona Hero, Martha Hurd, Stella Jatta, Mr. and Mrs. Peter Jones, Mr. and Mrs. James Morgan, Gertrude Schilling, Carrie Simpson, Gladys Wright, and Ocar Woltz. Son Einar Hero was involved with the livestock judging at Cal Poly. The Heros' pig farm, photographed here in 1970, was a local landmark known throughout many counties. Son Einar Hero always loved showing the pigs to the children at the local schools. When Al Dutra was on the city council, Dutra received a call from a neighbor complaining that a piglet was in the road. Dutra called Hero, and Hero rescued the piglet. (Author's collection.)

Four

THE JAPANESE INFLUENCE

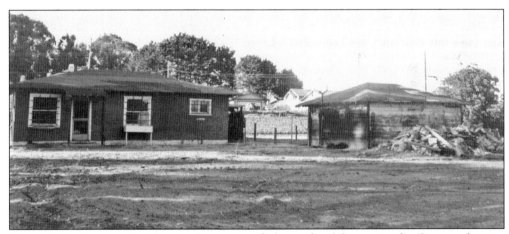

Some of the Japanese families in this area settled outside of Grover in the Cienaga district. One family was the Hayashi family. They were vegetable farmers. Their son, Haruo, attended grade school in 1932 with John Loomis, Gordon Bennett, Roy Tanaka, Don Ewing, and Yoshi Nakamura. Yoshi's family owned Nakamura's grocery store in Pismo Beach. Yoshi Nakamura married an Okui. When the Nakamuras returned to the Grover area in 1944 from an internment camp, they had to start over and find a way to support the family; farming strawberries was their answer. The huge parcel was purchased lot by lot. Eventually, the strawberry stand took hold, and the family called it Okui Strawberries. These buildings remain on the property. (Author's collection.)

According to Charles Okui, his parents began farming strawberries in Grover on South Thirteenth Street in 1948. The first lot purchased eventually became 30 acres of precious soil. Preparing, disking, and planting the berries during October gave a picking time from February through August. The rain in the winter meant the plants did well. Clear plastic mulch with perforated holes was used so the soil could breathe. The plants initially come from the north, where they are raised in colder temperatures and a higher elevation to make them stronger. When they are brought to the lower elevation of Grover, they have a lot of vigor and generate a lot of fruit. They are shipped to Grover in boxes, and the plants are about 5 inches tall. The Okui family has maintained good communications with their neighbors regarding the farming process, including the movement of equipment onto the site. The strawberries, when ready, are picked, packaged, and stored in these buildings, pictured here, until they are shipped east. (Author's collection.)

This early 1970 photograph of the 30-acre parcel on South Thirteenth Street is the acreage next to the industrial area of Grover. California has always had the toughest agricultural regulations. This field produces 3,000 crates of strawberries each season. Charles Okui remembers picking strawberries as a child in his parent's strawberry fields and realizing it was the most fun he could ever have. The Okui family was always thankful that the pickers were good workers and always appreciated everyone's hard work. The family knew it took time and effort to get a good product to the consumer. The Okui strawberries are the Chandler variety, and only a few places grow these berries. This variety is known to be large and sweet. When the strawberries are picked, packaged, and shipped out by truck, the trek to the East Coast markets takes four to five days. (Author's collection.)

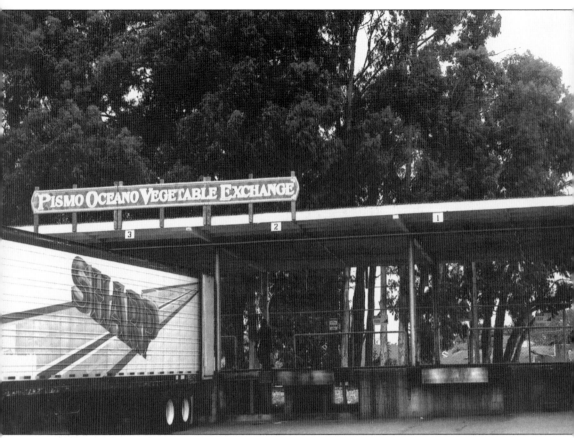

Grover did not have the necessary soil composition for Japanese truck farms, although the neighboring areas did. Once there were 40 Japanese farmers in the area, all working and pulling together. As early as the 1920s, this area was known for pole beans. In order to transport the produce to the East Coast, the farmers formed the Pismo-Oceano Vegetable Exchange (POVE) in 1930. POVE proved to be an excellent opportunity to move the crops from the rich agricultural areas surrounding Grover to the East Coast. During World War II, the Japanese farmers were relocated to internment camps. Of the 40 families making up the POVE, only 5 returned to the area from the camps—the Ikeda, Hayashi, Kobara, Saruwatari, and Dohi families. The POVE buildings shown here are much the same as they have always been. (Author's collection.)

Five

PIONEERS OF GROVER CITY

In 1920, Al Dutra was born in Bicknell, a community outside of Santa Maria. He moved with his family to Ontario Hot Springs (Avila Hot Springs) when he was one year old. Dutra loved being a part of the Fairgrove Fire Department, which started in 1946. He purchased a Grover lot in 1947 for $500. On nights and weekends, he and his wife, Billie, built the house on Newport Avenue. The house he occupied in Grover for 30 years had two bedrooms with 1,000 square feet. Except for one U.S. Navy tour of duty, Dutra always lived in Grover. In 1959, he applied for a position on the first city council. He lost but was appointed to the planning commission. This is his 1960 council photograph when he replaced Councilman Faye Keen. After 23 years on the council, Dutra retired in November 1984. Besides the fire department, Dutra listed as an accomplishment the support Grover received in 1954 to build a community-wide sewer system. Grover had outhouses until 1955; after that, septic tanks became the norm. (Courtesy Dutra family.)

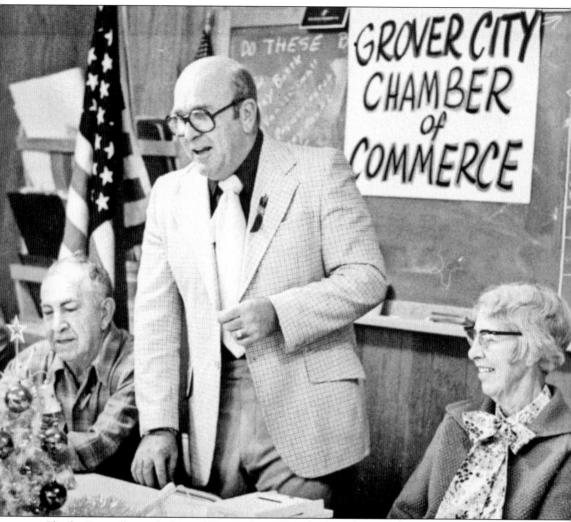

Charles Bagwell was the son of Horace Bagwell. Charles knew Grover's streets because he had dug most of the street trenches during his school summer breaks. In 1950, the town of Grover was small, and building was substandard. The streets were either sand or rock, and there were ruts in the roads. The main building in town was the dairy on Grand Avenue. It was originally the property of John F. Beckett. There were 25 homes in the area. Slowly, the eucalyptus trees were removed from Grand Avenue; Charles welcomed this. The only entrance and exit to and from Grover was Highway 1. Charles Bagwell served as the city's first mayor on the night of incorporation. He held positions on the city council for years; dabbled in real estate; worked with the Grover City Civic Association, the chamber of commerce, and the (first) Men's Club; and lived in several homes in Grover. This photograph of Charles Bagwell was during a 1959 chamber of commerce meeting. Pictured from left to right are Alfred Dutra, Bagwell, and Hazel Ewing. (Courtesy of Jean Hubbard Archives.)

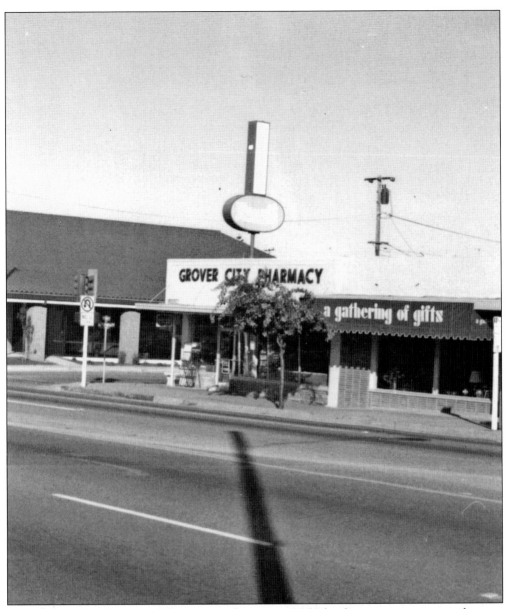

Eugene (Gene) and Gracia Bello came to this area in 1956 for the opportunity to purchase an existing drugstore and start their own pharmacy, which is shown here. The Bellos purchased the business from Cecil and Lorene Beebe. In 1959, they began the construction of the home they would occupy for more than 40 years. They raised three sons, all educated at Cal Poly. The Bellos met in a chemistry lab while both were pharmacy students at the University of Southern California. When they arrived in Grover, eucalyptus trees lined Grand Avenue, and most of the houses and trailers on lots were temporary homes. Eugene remembered the fire department's nightly burns as the short-term housing proved to be an ample burning training ground for the department. Also remembered was the pounding of nails as people came home from their day jobs to work all night building their own homes. Eugene was a member of the first Christmas Parade committee. Gracia remained skeptical "that the (Grand Avenue eucalyptus) trees had to be removed for future parking needs." (Author's collection.)

In 1933, Hazel Ewing lived in Arroyo Grande in the only house at the corner of Elm Road at Fair Oaks Avenue. Hazel and her husband, Barney, took a lunch and traveled Grand Avenue from Halcyon Street; they got stuck. Barney pulled slabs from the trees, like these on South Thirteenth Street, laid them in front of the tires, and drove on. They traveled 200 yards and then did it again. (Author's collection.)

In 1945, the Ewings purchased 10 acres from Leo Brisco for $2,000. It butted up to North Eighteenth Street in Grover. Grover did not have running water. The water tank photographed here in 1970 was put on the hilltop in 1951. Grover incorporated in 1959. Hazel Ewing requested that the Town of Grover bring water to her property; Grover responded, and Ewing's acres became part of Grover. (Author's collection.)

According to Sherry Lange, pictured on the right in 1980, her grandfather Clarence Dennis came to Grover in 1920. He put the first pole in for electricity. He put one in a wagon, hitched a team, went up the hill, stopped, and dug a ditch. He put the pole in the ditch, packed the dirt, and drove to the shop to unhitch the team. The process took one hour. (Courtesy Elsie Greenmyer.)

Victor Chapman began a nursery in 1960 at South Thirteenth Street. After his retirement, he sold the land. Before the land was a nursery, the acreage was the Sato family's strawberry fields. Ron Carlock took over the nursery after 1970. This 1970s photograph is of Ron's R&R Nursery under construction. In 2000, Ron's suffered a near-complete fire loss but was reestablished. The landmark continues to flourish. (Courtesy Ron Carlock.)

The photograph above is of David Ekbom and his mother, Esther, in 1970 working inside their mini-mart. David, his mother, father, and sister Nancy (Nan Fowler) moved to the Central Coast in 1961. David was born in Minnesota and raised in Oregon. From the Central Coast, he joined his sister on what he termed as "an adventure" to Southern California; after returning to the Central Coast, he purchased this mini-mart. The photograph below shows the mini-mart at the corner of Grand Avenue at Thirteenth Street. The mini-mart was a 500-square-foot, two-story house moved in 1948 from Pismo Beach. The Mobil Service Station, an eight-space trailer park, and Meeks' Electric were on the corner. David purchased it, remodeled it, and added a laundry. The site is known as the Corner Tree Market because David's last name, Ekbom, translated from German means corner tree. (Courtesy David Ekbom.)

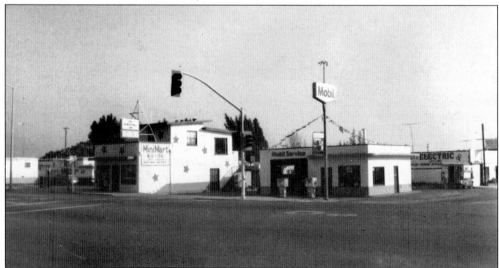

A drugstore, a ladies' shop, the Grover City Bakery, the U-Save Market, and the Grover City Feed Store were downtown in the early 1950s. Alton and Sally Lee built the feed store. The post office was originally in Baker's Store; Mrs. Baker was the postmaster. The post office building opened in 1948. The U-Save Market was owned by Booker Boren, Braxton Swack, and Jimmy Frye. The photograph here is the store when Boren, Swack, and Frye first purchased it in April 1951. (Courtesy the Braxton Swack family.)

Robert Hullette and his wife came to Grover in 1959 and purchased this building in the 800 block of Grand Avenue. The Pay Station moved next to the department store Robert opened in his newly purchased building. He remembered that the sheriff's department was stationed in Grover during 1959 because Grover did not have a police department. (Author's collection.)

Fred and Janet Maas purchased a liquor license and moved the license to Grover. The F&M Liquor Store, pictured here c. 1970, was located on Grand Avenue. In the 1950s, it was called the Pismo Beach Eagle Café. In 1952, Fred's flatbed truck moved it. Marin and Saviel built the King of Clubs next to the store. According to Janet Maas, "There was nothing here 44 years ago but a clump of old trees." (Author's collection.)

Morgan Page was a part of the volunteer fire department when it was the county's Fairgrove Fire District. This 1957 photograph shows part of the volunteer fire department team; Morgan is at right on the back of the truck. In 1960, Page was appointed the city's first superintendent of pubic works. He dedicated his life to service in the community. (Courtesy Grover Beach Fire Department Archives.)

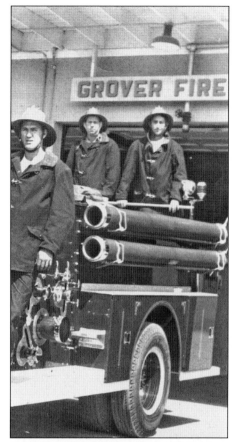

Lloyd and Juanita Qualls arrived in Grover in 1944. They purchased property on Longbranch. Sometime later, the Qualls purchased acreage from Charles Bagwell for $2,500. This is a photograph of that property around 1984 off of Eighteenth Street and Brighton Avenue. The Qualls eventually sold five of the six parcels they owned. (Author's collection.)

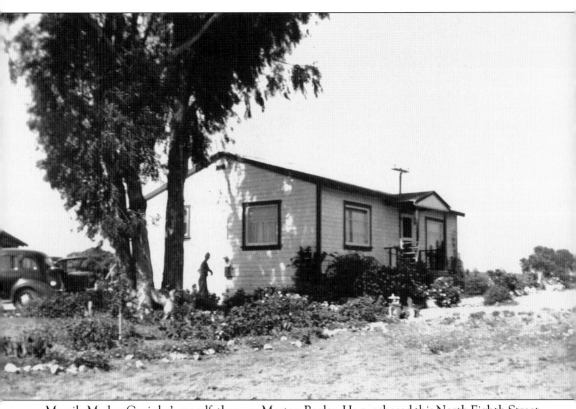

Marcile Mosher Capinha's grandfather was Morton Bagley. He purchased this North Eighth Street at Atlantic City Avenue property in 1941. It was almost an acre with more than 100 chickens, two chicken houses, and a brooder. The Japanese grocery stores were her grandparent's customers as Bagley gathered and hauled the eggs to Nakamura's Market in Pismo Beach. When the area's Japanese population was deported to internment camps during World War II, Marcile said the chicken farms "went to heck." Her grandfather stood at the top of the hill on Atlantic City Avenue and counted the troop trains that went by. Ships were visible from his property. Mr. Bagley grew vegetables, including tomatoes, corn, and asparagus. About a half-mile from her grandfather's place was the Pismo water tank. Between Bagley's house and the water tank was one house and brush fields. One night they heard noises and saw flashlights. Everyone had black-curtained windows because it was wartime. Bagley drove to Pismo with his vehicle's lights off, and he made the police go to the tank to check for invaders. (Courtesy Marcile Capinha.)

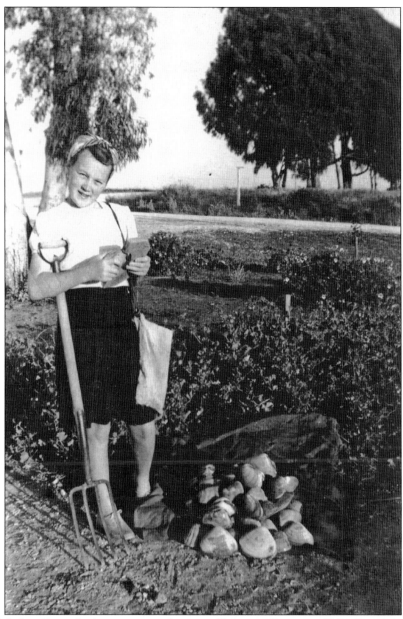

Marcile Mosher Capunha began visiting her grandfather in Grover in 1941. Grand Avenue was two lanes and lined with eucalyptus trees. The new post office was visible from her grandfather's property. When the Japanese Americans were moved to the internment camps, her grandparents lost their chicken farming business. Her grandfather got a job in a bakery; her grandmother worked in the snack shop at the junior high school. The school was on Marsh Street at Johnson Street in San Luis Obispo. Highway 1 was a huge artichoke field between Pismo Beach and Grover. This photograph, taken in 1942, shows Marcile with a clam fork and the results of her latest clam dig at the beach. According to Capunha, "We would clam all the time. We drove down to the tracks and then made our way through the willows; we climbed over the sand dunes." Capunha does not remember many people driving on the beach in Grover, but people drove on the beach in Pismo. (Courtesy Marcile Mosher Capunha.)

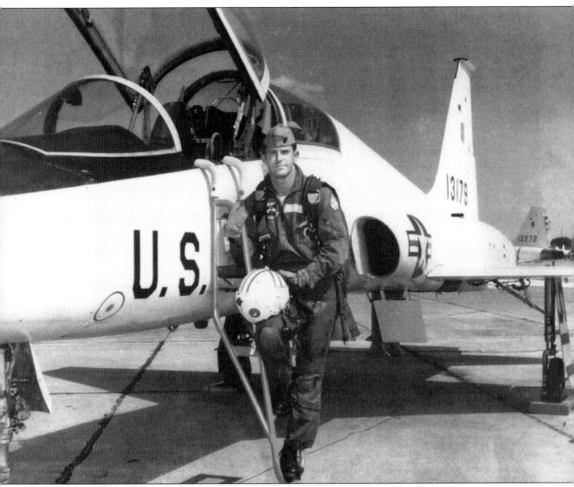

In 1950, Grover was unincorporated. Building requirements consisted of taking plans to the county office. A permit was not necessary, and water was simply turned on. Grover incorporated on December 21, 1959. The first order of business was the general plan. In addition to a city attorney, Grover City embraced the engineering firm of Garing and Taylor. Garing and Taylor Engineering opened in 1962. Mr. Robert Garing Jr. arrived in Shell Beach in 1951. His son, Robert S. (Jim) Garing Jr., attended San Luis Junior High and San Luis High, as well as Cal Poly, and taught school before he enlisted in the armed services. This c. 1969 photograph of Jim shows his determination and stance in flight gear while in command of a F-4 Phantom jet fighter. He flew 136 missions in Vietnam. When Jim left the service, he wanted to return to what he loved. His father indicated there was room in the engineering firm. Because Jim already had a Cal Poly mechanical engineering degree, he undertook four additional years of study, which resulted in a certified civil engineer degree. Jim became Grover's city engineer. (Courtesy Robert J. Garing.)

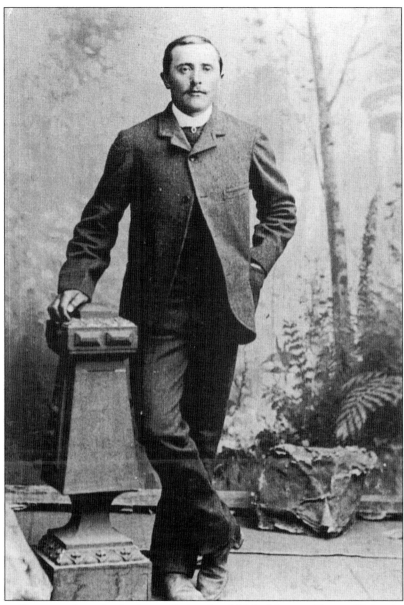

Bartolomeo Barca was born in Aurigeno, Switzerland, Valle Maggia, Canton Ticino in 1860. He immigrated to the United States on July 4, 1878, to Stockton, California. For six months, Barca worked on dairy ranches in Napa and Sonoma. He relocated to St. Helena and then to San Luis Obispo County. Barca became an American citizen in San Luis Obispo on August 2, 1886. In 1901, he returned to Switzerland to marry; however, it was too long of a wait that resulted in the promised woman marrying someone else. She suggested he marry her daughter. Agreeing, he married Virginia Grossini. In 1904, approximately the date of this photograph, Barca acquired a 2,108-acre ranch in Los Alamos Valley (Santa Barbara County) on San Antonio Road. The ranch was a portion of the Todos Santos y San Antonio Mexican Land Grant. In early 1900, the Barcas began to purchase other California properties. A 1903 map shows the Barca name on lots they purchased in Grover. The area was known as the Pismo Beach Gardens off Farroll Road. (Courtesy Janice Barca Battles.)

Howard Sharps was an architect and is remembered as a great builder. Sharps built the grammar schools in the area, homes, and the dormitories at Cal Poly in San Luis Obispo. Sharps is pictured in the middle of this 1972 photograph. He and his brother John enjoyed ocean fishing. (Author's collection.)

Bruce Tyerman moved into his business at 1135 Grand Avenue on August 1, 1958. His dad had a Tyerman's store in Santa Maria and one in Burbank. During the 1940s, Tyerman's in Burbank was the only place that could fix a hook and ladder. This 1960s photograph shows Bruce, on the left, and Jonathan Winters, standing. (Photograph Bruce Tyerman.)

Lloyd Qualls, pictured here in the late 1940s, was the fire chief when the department purchased its first truck. Qualls was on Grover's planning commission, helped build the cannery off of Fourth Street in 1951, and built the Youth Foundation Building. Horace Bagwell and Qualls had a 19-day fishing trip one time. Horace slept in a chair with an umbrella and a fishing pole. (Courtesy Walter Galloway.)

This photograph of William and Roberta Smith was taken during World War II. The Smiths moved to Grover in the 1940s to North Sixth Street. The backyard was a field of brush and shagbark manzanita. Roberta's mother, Georgia Brown, was a teacher in Paso Robles, California. The Georgia Brown Elementary School is named after her. (Courtesy Roberta Smith.)

This photograph (left) of Vic Walker is evidence that he was a great traveler as he had been in the service at Fort Lewis, Washington. In 1952, Walker arrived in Grover. He lived on Atlantic City Avenue where Grover Heights Park is today. Walker purchased the property from Sheriff Mansfield's parents. Vic and Mary Walker had Walker's Succulent Gardens. When San Luis Obispo County wanted property on the north side of Grover for another school, they made Walker an offer. The photograph below was Vic Walker's Gun Shop in Grover. Around 1959, Walker moved from the Atlantic City Avenue house to another and located this new shop at Thirteenth Street and Grand Avenue. Joe Angello built the new home and shop. Vic sold the gun shop. He remains an expert in his field. (Photographs Courtesy of Vic Walker.)

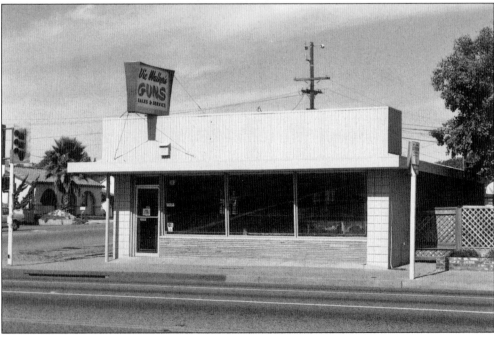

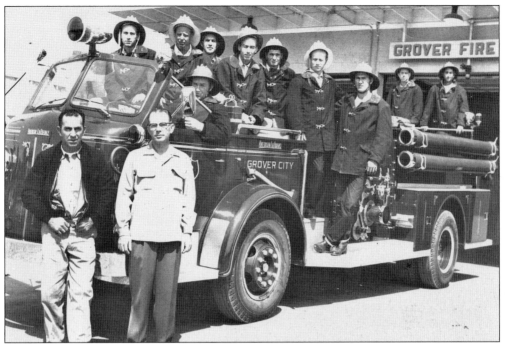

Grover's fire department was photographed on September 13, 1957. The first truck ordered from Massachusetts traveled by boat through the Panama Canal to Sacramento. Four firefighters traveled north to see the gold lettering placed on the truck. The photograph of the fire men, from left to right, includes (standing) Alfred Dutra and Fay Keen; (driver) Lowell Forister; (back row) Glenn Miner, Ed Stevens, Coy Walker, Lee Miner, Bill Glenn, Jim Harner, Joe McGowne, Ralf James, and Morgan Page. (Courtesy Grover Beach Fire Department.)

In 1957, Paul Hearn, Hardy Hearn, Hooker Boren, and Pauline and Braxton Swack bought an old house (with the sign "Pocketbook Market" on the front door) on Pismo Road. Paul Hearn, Pauline's father, remodeled it in 1957 and included a parking lot. Pauline and Braxton Swack bought out the others; Braxton Swack ran the market for 19 years. The Swacks sold the market in 1984. The original owners of the house were named McGee. (Author's collection.)

Glenn Bolivar, pictured here in the mid-1970s, said his father, Antonio, left the Philippines in 1940, arrived in San Francisco by boat, and then traveled to Guadalupe, California. Guadalupe, at that time, was a Japanese town. The first group of Filipinos who came to California became migrant workers. Many enlisted in World War II. The G. I. Bill enabled Filipinos to purchase property; Antonio settled in Grover. (Author's collection.)

The Grover City Bakery was owned and operated by the Carlocks and was in the middle of the 900 block of Grand Avenue. Clyde Carlock was a terrific baker. Their specialties were cakes and pies. This 1960 photograph shows Margaree Carlock with rolling pins, mixing bowls, and freshly baked cakes. (Courtesy Ron Carlock Archives.)

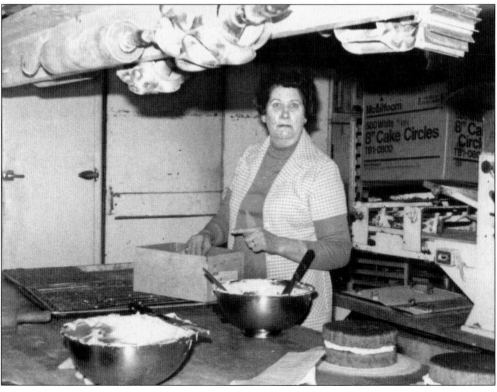

Six

OLD CHURCHES, HOUSES, AND BUILDINGS

Bethel Baptist Church rooted itself in Grover City with its first congregation in December 1961. The necessary church incorporation papers were filed in 1962. The first church meetings were held in private homes on a rotation basis. From private homes, the congregation moved their services into the large Grover City Women's Club on Eleventh Street at Saratoga Avenue. In 1962, the church settled in Grover on a piece of property on Newport Avenue off of Oak Park Boulevard. During 1962, the church purchased the Newport Avenue property. The church remains in the same place, although there is a large addition to the east of the main sanctuary, which is visible in this photograph. The addition has classrooms, meeting rooms, and an area for informal and formal events. (Author's collection.)

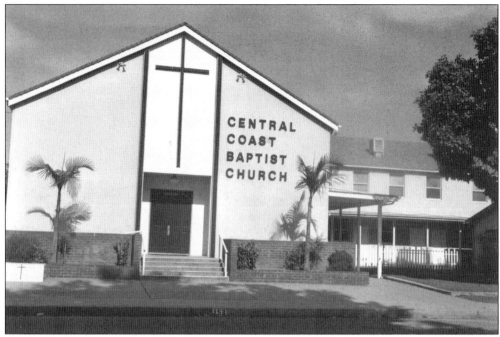

Central Coast Baptist Church began in 1943. It moved to the corner of Grand Avenue at South Ninth Street in 1960s and prospered there until the congregation outgrew the building and moved around the corner in 1970. This photograph was taken in the mid-1980s. (Author's collection.)

The first church built in Grover was constructed in 1941 between North Eighth and Ninth Streets on Ramona Avenue. It was called the Community Church, which became the Church of the Nazarene in 1950. The congregation moved until they settled in a new building on Oak Park Boulevard at Newport Avenue. (Author's collection.)

The Grover Community Mission Church (1930–1940) was located on Ramona Avenue between North Eighth Street and Ninth Street. During the church's early years, Ramona was a dirt road. The building was remodeled several times. Today the church stands on the same site as it did in 1930. The name on the church is Mt. Zion Missionary Baptist Church. (Author's collection.)

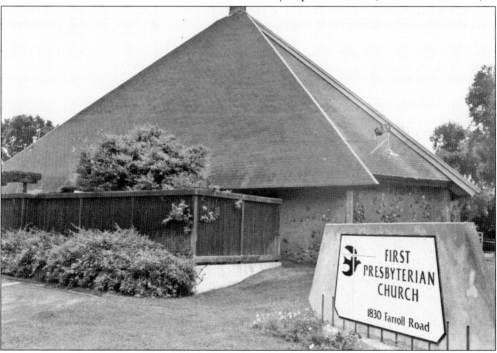

The church pictured is the second congregation to gather under its roof. It began as St. John's Lutheran Church in 1966 on a five-acre parcel located on Farroll Road in Grover. St. John's Lutheran Church encountered difficulties and sold the sanctuary and acreage. The First Presbyterian Church chartered and occupied the building in 1993. Pastor Jan Bruce Armstrong guides the congregation today. (Author's collection.)

45

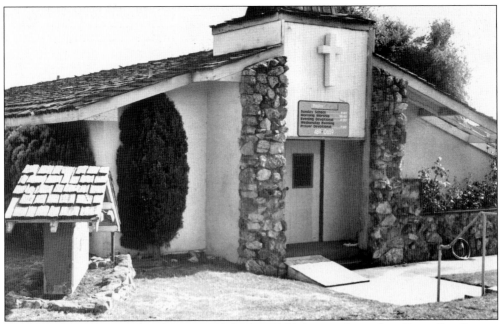

The Missionary Baptist Church was established in 1956. It was a barrack at Camp San Luis in San Luis Obispo. In 1959, the church was moved to Newport Avenue. Pastor Thurman Miller has been the church's leader for the past 31 years. The church has a study, a nursery, two large classrooms, and a baptismal station. (Author's collection.)

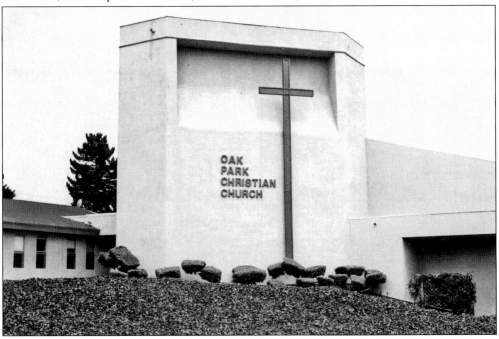

In 1985, Oak Park Christian Church took over the space formally occupied by the Church of the Nazarene until 1986. (The two congregations shared it for one year.) When the Church of the Nazarene left for Pismo Beach, Oak Park Christian Church began. Senior pastor James Shields and associate pastor Mike Gunderson guide the congregation today. (Author's collection.)

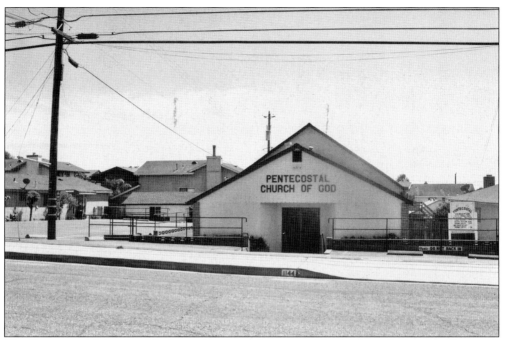

The Pentecostal Church of God is on Brighton Avenue on North Eleventh Street in Grover. It was erected in 1940. It looks the same today as it did then. Brighton Avenue is no longer a sand street or a dirt road. The paved parking lot was added. (Author's collection.)

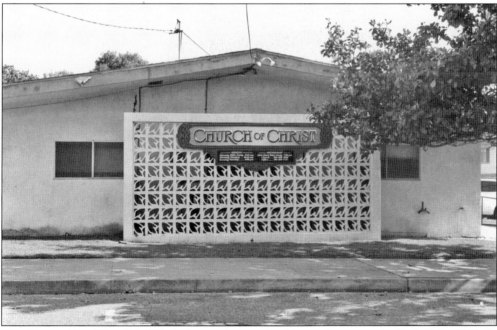

The Grover City Church of Christ has an interesting history. It was originally built in 1946. In 1962, the church building was moved to Twenty-second Street in Oceano, and the congregation built a new building at the corner of South Eighth Street. In 1982, a second story was added to the church building. (Author's collection.)

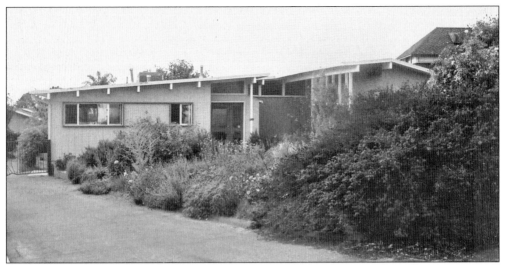

In 1960, Editor Blankenburg Sr. moved into this Sixth Street home. The hired contractor paid all permits, plan check fees, and utility connection fees. Lunsford Drafting Service gave instructions as part of approved plans, stating, "The contractor, at completion, shall leave premises broom clean, windows and fixtures washed and cleaned, and all debris removed from the site." (Author's collection.)

The house with the white roof in this 1970 photograph is the Bello house. Eugene and Gracia Bello began building it in Grover City Heights in 1959. This home featured a unique design of light, levels, and intrigue. The hills in the photograph show a pristine Pismo Beach. (Author's collection.)

This 1970s photograph of a Saratoga Avenue house shows the east side with the original windows facing North Thirteenth Street. This one-bedroom, one-bath home was built in 1946 and contained 240 square feet on a 10,000-square-foot lot. A remodel added 448 square feet. There is a majestic oak tree in the front yard. (Author's collection.)

These are the 1950 mail-ordered Sears cabinets in the 1948 Addie Treat home on Atlantic City Avenue. There are pull-out wire rack sleeves instead of shelving inside the cabinets. The handles are original, as are the countertops. Addie first married George Rockholt; she later remarried, becoming Addie Treat. (Author's collection.)

This is a 1973 photograph of a Charles Bagwell home located in Grover City Heights. The property ended on the dead-end street named Charles. Charles Street was carved into the hillside by the City of Grover during the late 1960s and was named in honor of Bagwell. This home was built by John Foremaster, and Charles sold it in 1973. There was one other home on the street. (Courtesy Patricia and Angelo Lombardini.)

Charles Bagwell's home in Grover City Heights, photographed here in 1968, was on North Sixth Street and was designed in 1954 by architect Howard Sharps. Charles's father, Horace Bagwell, gave him these lots in Grover City Heights to build on because Horace was convinced the house would always have a beautiful view of Pismo Beach. (Author's collection.)

When Phyllis Gardner was a child, she would come to Grover to visit her grandparents, the Kirchers. Jacob Kircher was her grandfather. Kircher heard about the 1931 Long Beach earthquake. He decided he could use the lumber that was lying around from the earthquake to build a house in Grover. He drove to Long Beach and brought back lumber from a school demolished by the quake. In 1932, Kircher built this dwelling in Grover with that lumber. It was constructed on the dirt road in the 1600 block of Brighton Avenue. The property was a 1-acre commercial lot. There was an enormous oak tree toward the back. There were several smaller oaks and an abundance of wildflowers down the dirt road, including California poppies, lupine, owl's clover, and wild anemone. The house was built on the lot's northeast portion. It did not have a bathroom, so Kircher built an outhouse. The first section of the house was a great room, with a stove that was fired up 24 hours a day and used for heating and cooking. (Courtesy Phyllis Gardner.)

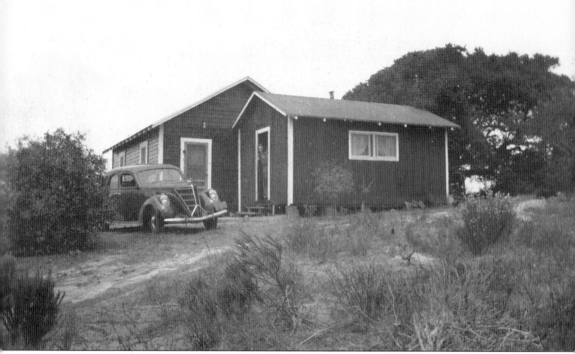

In 1931, people built their homes at the back of their property as the front was used for little truck farms. When Jacob Kircher separated from the Spanish-American War, he settled in the town of Grover. He was with naval intelligence during the war, so when the war was over, he had a job helping the government. He did not tell the government that his family lived in Grover; otherwise he would have been moved to a different area to watch for submarines. He would go to the end of Grand Avenue and look for boats that were floating. There wasn't any water to the property, so Kircher dug two wells, one for use inside the dwelling and the other for the outside. This dwelling was constructed in three phases. This is a 1934 photograph of the second phase, which added a sun porch on the right side of the main house. The car belonged to Phyllis Gardner's grandparents. In those days, there were few cars in the area. While people had horses, for the most part, people walked. (Courtesy Phyllis Gardner.)

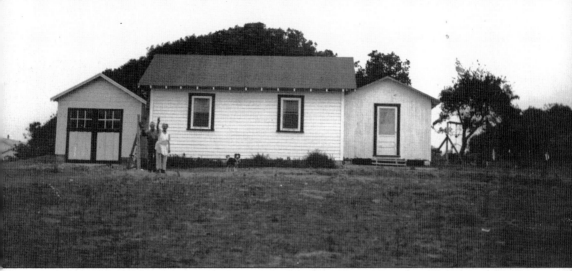

In this 1934 photograph, Jacob and Mary Kircher stand in front of their completed house. Phyllis Gardner and her brother played within view of this home. There were cows on the north side of Grand Avenue at Eighteenth Street, which provided them with another play area. When out of range, the two children would wander through the cow pasture and head over the hill and down to the area near El Camino Highway. There was a cement house in that area just north of Eighteenth Street. The children made friends with the owner but never knew his name. He was a beekeeper. The children's grandfather would send them with arms full of vegetables from their Brighton garden down to the man. In turn, the children would bring home honey from the hives of "Bee Man." Phyllis's mother enjoyed the Grover life (she was born in Carlsbad and visited Grover before moving there after college), raised a cow for an agricultural project, sold the cow to finance her education at the University of Southern California, became a teacher, taught at Margaret Harlow Elementary School in Arroyo Grande, and ended her career at Oceanview Elementary School in the same city. (Courtesy Phyllis Gardner.)

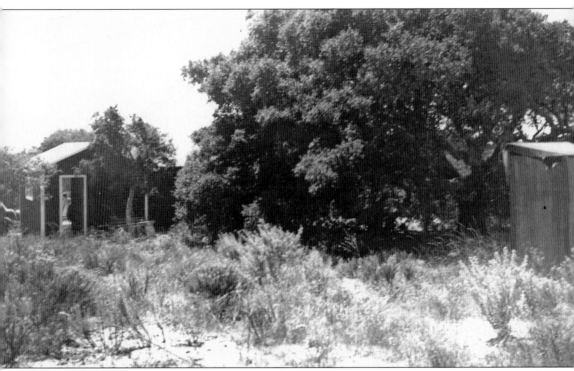

This photograph of the back of Jacob Kircher's dwelling on Brighton Avenue shows the original one-room house with the outhouse next to the oak tree. The south side of Grand Avenue at Eighteenth Street was a large turkey farm and fields as far as the eye could see. For Thanksgiving, a turkey was dressed, taken to the Pismo Bakery to be roasted during the night, and picked up Thanksgiving morning. Leftovers were placed in the cooler, which was a wooden box covered with damp burlap suspended from the oak tree. The only convenience was the outhouse. Water came from a well. There was an oil lamp for light. Five people and a dog named Skunk slept on the floor. To add indoor plumbing, in 1938 Kircher called Bates Plumbing. Once electricity and city water became available, Kircher's garden thrived. The children even had a tree house in the big oak. The house and oak tree are still on Brighton Avenue in Grover Beach. It is a glimpse of Grover's beginnings. (Courtesy Phyllis Gardner.)

Jess Monroe worked in the Taft, California, oilfields. Monroe purchased lots in Grover. He built a home and a concrete tower on one lot. The tower was on top of an old wellhead. The tower's landmark was visible from El Camino Highway. This 1980 photograph is of Monroe's home. The well was capped, and the tower was removed in a 1966 Grover fire department controlled burn. (Author's collection.)

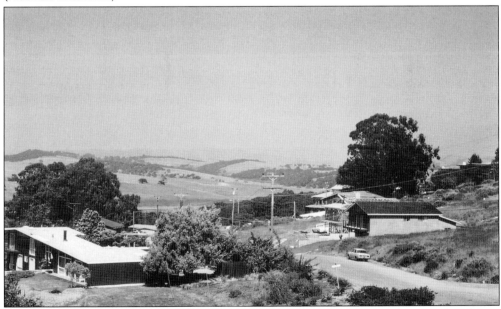

In 1975, Charles Bagwell began the construction of this home in Grover City Heights. It was fashioned after a Spanish hacienda. It was all white on the outside with a tile roof. It boasted a sunken living room and two bedrooms downstairs with parking underneath the living room. (Author's collection.)

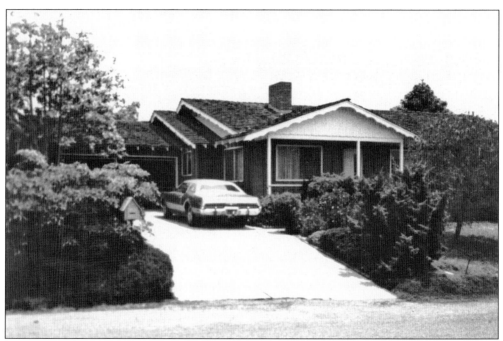

Lloyd Qualls built this house in 1940 in Grover for Archie and Florence J. Kyle on the corner of Ocean View Avenue and North Sixth Street. William R. and Mildred Higdon purchased it on May 5, 1971, from the Kyles. It had the trim that was popular during that era. (Courtesy of Roberta Smith.)

John Foremaster built this home in 1968. Morgan Page, the superintendent of public works for Grover, owned and lived in the house, which was constructed after Grover put Charles Street through to the dead end. This house boasted a composition roof, fireplace, front arches, and a double-car garage. (Author's collection.)

Robert Tennant was a member of the Grover City Water District Board. The Tennant house, pictured here in 1980, was on North Ninth Street. Martha, Robert's wife, had a keen sense of humor. After a Grange meeting, she was told not to stop at a bar. Her response was, "Are you afraid I'll see you there?" Martha passed away at the age of 104 in 2004. (Author's collection.)

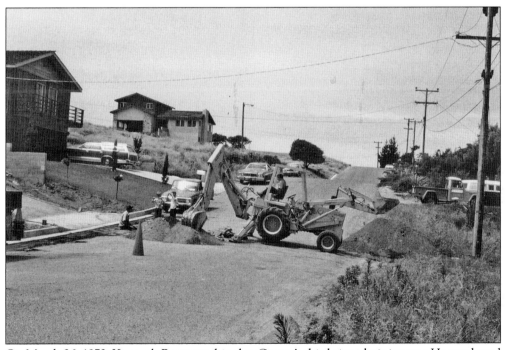

On March 26, 1973, Kenneth Berry was hired as Grover's third city administrator. He purchased a lot in the Grover City Heights Tract. Berry had equipment work on this project that did not belong to a construction company. What was captured on film here in 1975, along with other issues, hastened Berry's departure from Grover that year. (Author's collection.)

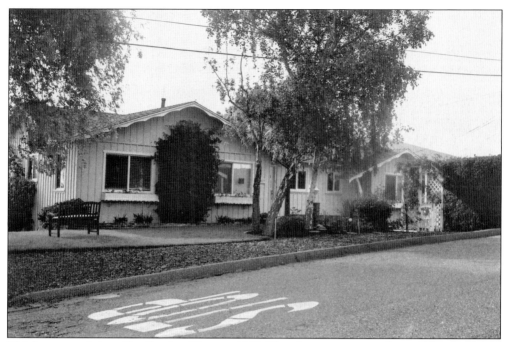

This home was designed by Cynthia Glenn in 1960. The white trim next to the roofline was typical for the homes of this era, as were the flower boxes. There was a composition roof, three bedrooms, two bathrooms, and a living room. The kitchen faced North Sixth Street. (Author's collection.)

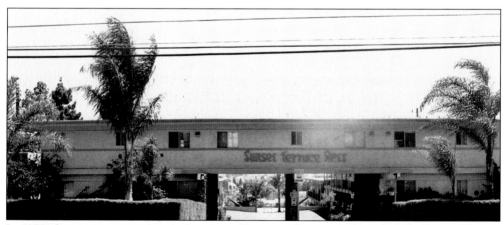

In 1970, there were two apartment houses in Grover with swimming pools. The Sunset Terrace Apartments on Brighton Avenue, pictured here in the 1970s, was one (the other was on Front Street). Dorothy Fidler from Bakersfield owned it. Lois Batey was the apartment manager. Batey was known to be handy with a hammer and a screwdriver. Mrs. Fidler always said she was going to fill the pool with concrete. (Author's collection.)

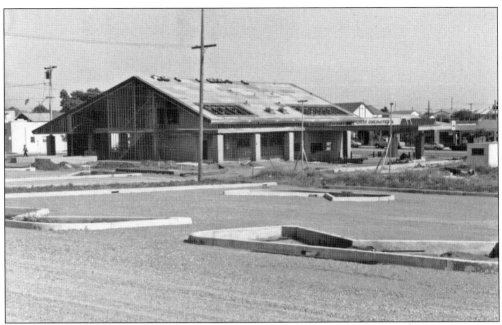

The *c.* 1980 photograph above of Mid-State Bank and Trust's Grover branch under construction was at the corner of Ninth Street and Grand Avenue. This was the second Grover branch of the bank. This building was a marvel with drive-up teller bays complete with a wooden canopy structure, front and back entrances, a separate entrance into the real estate section of the bank, and a night depository drop box. The 1963 photograph below of Mid-State Bank and Trust was the original Grover branch of the bank built at the corner of Seventh Street and Grand Avenue by John Foremaster. Before this bank, the locals remembered going into the grocery store in the 900 block of Grand Avenue to cash their paychecks on either the first or the third day of each month. (Courtesy Mid-State Bank and Trust Archives.)

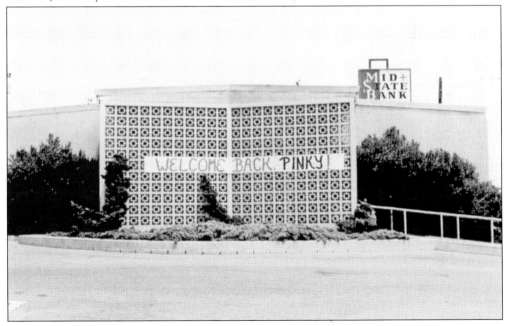

A Hole in the Sky began on Grand Avenue between Eighth and Ninth Streets in Grover in the early 1970s. This small business offered unique gifts, candles, and smoking items. It is the small blue building on the left side of this 1970 photograph. The business felt an attachment to the Dunites, people who populated the dunes. (Courtesy Mid-State Bank and Trust Archives.)

Grover was home to a Filipino community early in the life of the area. After World War II, the G. I. Bill made it possible for veterans who were Filipinos to purchase land. The Filipino Community Center, shown here, was built in 1970. The center's members were responsible for all improvements to the building and grounds. (Author's collection.)

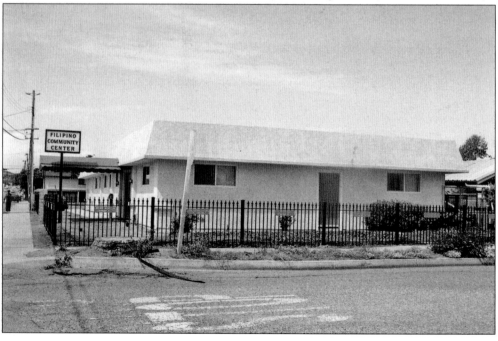

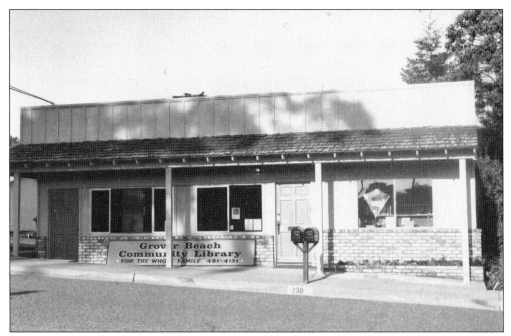

Attorney Clifford Clark came to Grover and rented half of this 230 North Ninth Street building. The citizens and the city needed counsel, so in 1962, Clark was appointed the city's attorney. Most of the building in this 1980 photograph was leased to the new Grover Beach Community Library, with a back area reserved for Clark's law practice. (Author's collection.)

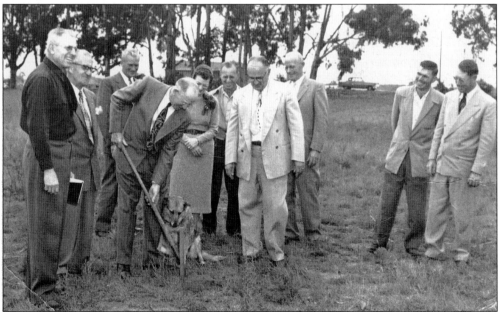

The Grover City Grange was organized in 1949. The Grange purchased a tree-lined, 1-acre lot in 1952 for its hall. The building had a stage, a kitchen, and a banquet room. This 1955 photograph at the ground-breaking ceremony shows Ford Davidson, Gerald Walker, John Curten, James and Mrs. Dykes, the Dykes's dog Pat, R. Alberti (Rubie), J. W. Gwin, Einar Hero, and Noel Stover. (Courtesy Grover City Grange.)

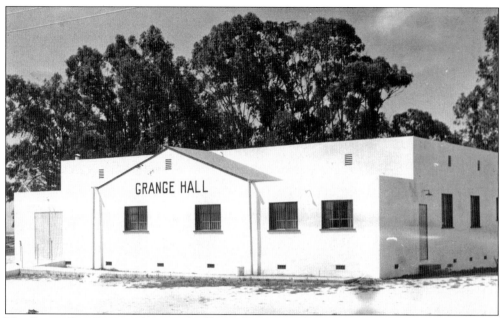

The Grover City Grange, photographed here after its completion in 1956, was the best California Grange Hall. The Grange scrapbook included articles about the Routzahn County Park (where Lopez Lake is today); when Grover's phone service increased in 1952; when an honorary mayor election campaign in 1953 to raise money for the Grover Park Fund came to be; when Juanita Qualls starred in a footlight revue production, while Mrs. Billie Dutra starred in the *Cupids Bow* production April 21–22, 1953, at the Shell Beach Women's Club; and when the Grange paid in full and in advance the $2,000 for their Grange Hall property in 1953. The Grange's civil responsibilities included involvement in getting approval for the proposed opening of Fourth Street to connect with Highway 101. The photograph below was one of the Grange assemblies; the meeting took place inside the new hall. (Both courtesy Grover City Grange.)

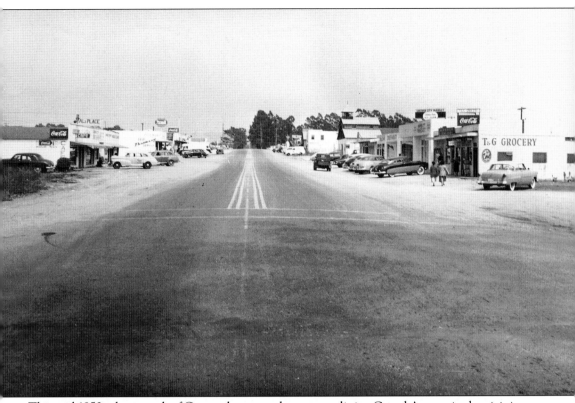

This mid-1950s photograph of Grover shows eucalyptus trees lining Grand Avenue in the vicinity of Eleventh Street and east from there. The tall building on the right with the steeple was the Baptist Church. The Grover City Market, the Barber Shop, and the T&G Grocery are on the right of the photograph. On the left is the Rexall sign visible on top of the building that housed the Self Service Pharmacy. In the block west of the pharmacy was the café known as Al's Place. The downtown had diagonal parking. Grover did not have a traffic signal. Grand Avenue was a two-lane street with no sidewalks. (Courtesy Wally and Jeri Lewis.)

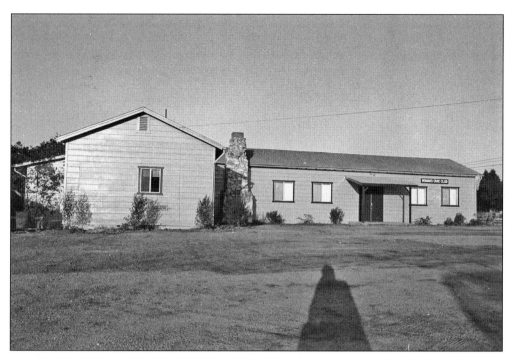

The citizens of Grover needed a place to meet and a place to shop. The photograph above is of the Grover Civic Association that later became the Grover Women's Civic Club. The building was on North Eleventh Street at Saratoga Avenue. It was built in the early 1950s. It was also a meeting place for several churches until they were able to fund and build their own sanctuaries. The photograph below is Giant Foods, built on the corner of Eighteenth Street and Grand Avenue. Williams Brothers eventually bought Giant Foods, although the Giant Foods' store in San Luis Obispo lasted a longer time. Dominic's Liquors rented the west end of the Giant Foods' building in Grover after previously inhabiting a structure located at Eleventh Street and Grand Avenue. (Both courtesy *Times-Press-Recorder*.)

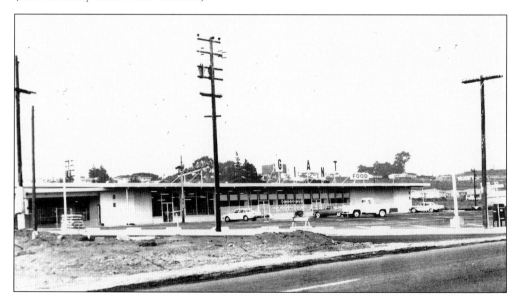

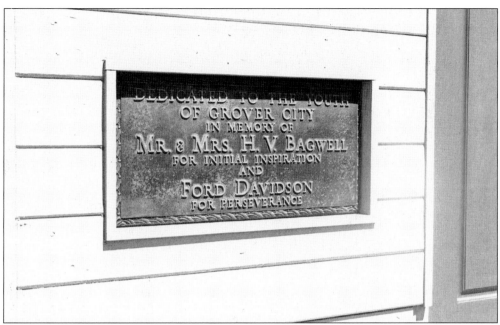

The photograph above is Grover's recreation center, which started out as the Youth Foundation Building. Lloyd Qualls helped construct the building. The plaque on the front of the building attests to the strength, determination, and character of Horace V. and Sadie Bagwell and Ford Davidson; the three were instrumental in the beginnings of the city and programs for the youth. The 1970 photograph below is the building that once was the Blinking Owl. It was a lively spot for the locals. The owner, Albert Cardova, was responsible for bringing entertainment to the Owl. He brought country-western stars Buck Owens and Meryl Haggard from Bakersfield to Grover and the Owl; Meryl's mother lived here. (Author's collection.)

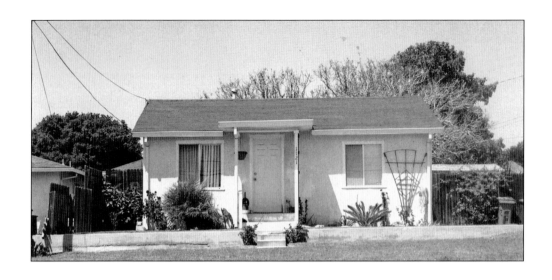

These 1970 photographs show two distinctly different homes. The white house in the photograph above was built in 1948 as a typical Grover-style bungalow. It was 598 square feet and was built on a 6,596-square-foot lot. It was one level with a porch. The Grover house shown below was built in the early 1950s by a contractor who planned on moving into it with his bride. The marriage did not take place, and the house was advertised as a rental. The Bellos rented it and eventually purchased it. They continued to live in it until their Grover City Heights' home was constructed. (Author's collection.)

In 1957, the Grensted Funeral Home opened on Grover's south side on Longbranch Avenue. This 1958 photograph shows a barely developed Grover. The area across Longbranch was brush and without streets. The original chapel consisted of two buildings with a courtyard. The funeral chapel was improved and became Marshall-Spoo Sunset Funeral Chapel; it remains an essential business in Grover. (Courtesy Arthur J. Spoo.)

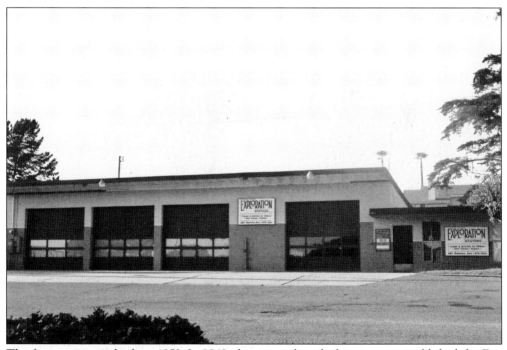

The fire station was built in 1952. In 1949, the county board of supervisors established the Fair Grove Fire District. Elected officials directed a volunteer crew, enacted a burning ordinance, and budgeted for equipment. The building was constructed on land deeded by the board of supervisors for $10,800. (Author's collection.)

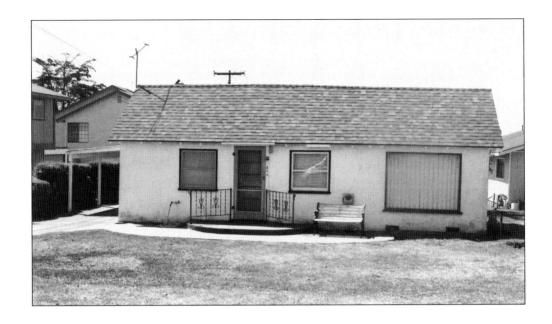

Grover had an array of houses built in the late 1940s and 1950s. The photographs above and below are of homes that are still a part of the area. When a home was refurbished, it boasted a composition roof, new windows, and a new front door. If the home did not have a breezeway to the garage, then it had a carport or a detached garage. Grover's mail service was curbside delivery, as opposed to front-door delivery. It remains the same today. Houses were generally less than 500 square feet and typically had a great room where everyone slept. The outhouse was in the backyard. The house shown below was in a residential area that became a commercial area. (Author's collection.)

When Grover's population began to increase, San Luis Obispo County's public health department opened a Grover City branch in the late 1970s off of Grand Avenue at South Sixteenth Street. The department had an array of services, and the small building became a permanent fixture. Across the street at South Sixteenth Street and Longbranch Avenue were acres of strawberry fields. As shown in the photograph below, the strawberry fields were replaced with acres of housing. No matter how many times the locals ventured down South Sixteenth, they were always shocked by the housing that took over land from the strawberry farmers. (Both Author's collection.)

In the 1950s, Horace and Sadie Bagwell lived in this home on Parkview Avenue at Fifth Street. Horace passed away in 1958, one year before Grover's incorporation. This was a corner house and had access to Pismo Road, which was later renamed to North Fourth Street. The house faced North Fifth. (Author's collection.)

This house, pictured during the 1970s, is an older home on Brighton Avenue. It sits on a huge parcel. The parcels in this area were large, and the owners built on the back of the lot in order to use the front as a vegetable garden. (Author's collection.)

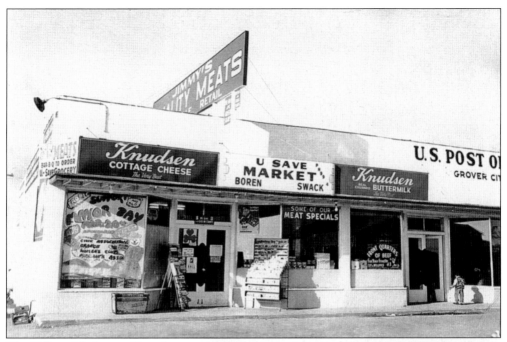

The U-Save Market on Grand Avenue was small when Braxton and Pauline Swack purchased it in 1950. As shown in the photograph above, the store was enlarged to more than twice its original size. Jimmy Frye of Jimmy's Quality Meats was in charge of the meat counter at the back of the store. Swack and Hooker Boren, Pauline's uncle, were in charge of the produce and all the commodities sold. The photograph at right shows Braxton Swack leaning on the counter. Notice the TV Sundae sign hanging from the ceiling, the 7-Up sign, and the Heath bars in a carton behind Swack. The Swacks sold the market to Wally and Doris Barr in 1964. (Both courtesy Braxton and Pauline Swack.)

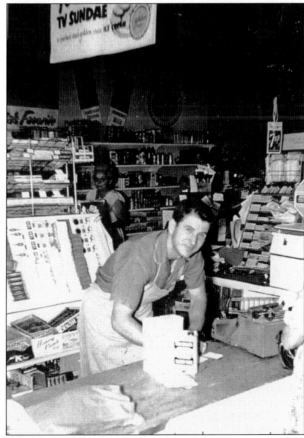

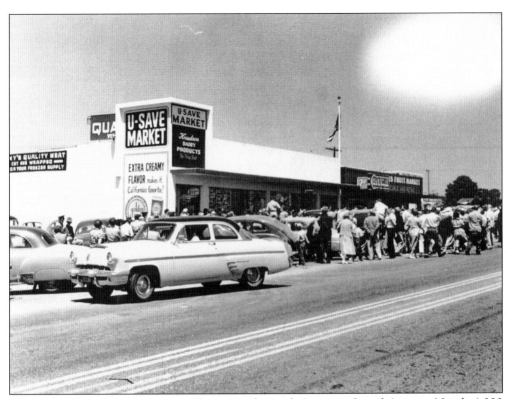

This early 1950s photograph above shows North Ninth Street at Grand Avenue. Nearly 1,000 people attended the reopening of the new and enlarged U-Save Market. Downtown housed the drugstore, a ladies' shop, the Grover City Bakery, the U-Save Market, and the Grover City Feed Store. The post office building opened in 1948; previously, it was located inside Baker's store across the street. Mrs. Baker was the postmaster. Alton and Sally Lee built the Grover City Feed Store. The U-Save Market was owned by Booker Boren, Braxton Swack, and Jimmy Frye. The photograph below shows the store when Boren, Swack, and Frye first purchased it in April 1951. Mr. Carlock owned and operated the Grover City Bakery next door. (Above, courtesy the Braxton Swack family; below, the Ron Carlock family.)

Seven

GROVER CITY LANDLOCKED

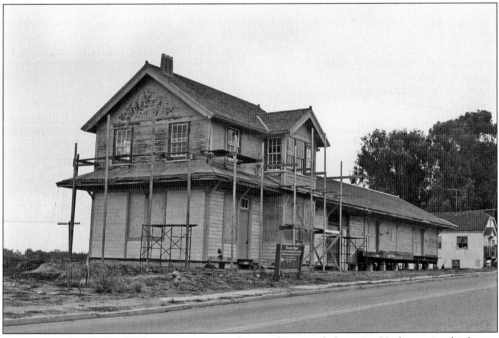

Grover was landlocked. There was one road in and out and that was Highway 1, which was on the west side of the railroad tracks. Grover had the Pacific Ocean to its west beyond the tracks. Grover was landlocked to the south with Oceano as its southern border. Oceano created a boundary with Grover that was a county area composed of part beach, part residential area, and part commercial district. It had agricultural fields that were half inside of Grover and half within the county area. This photograph captures the remodeling of the Oceano Train Depot. Harold Guiton spearheaded the drive to move the depot to its new location, just south of where it originally was, and to preserve it. (Author's collection.)

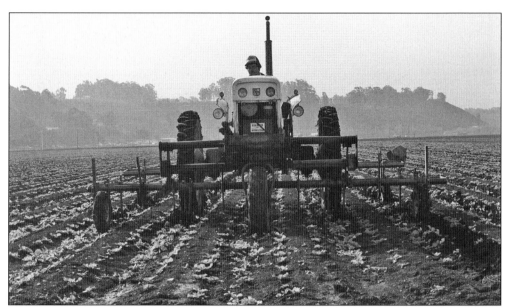

The Grover farms during the early 1970s were strawberry farms. Machinery worked until the last light of day. During the early 1970s, strawberry fields were on South Thirteenth and South Sixteenth Streets at Manhattan Avenue. Grover's farms were eventually surpassed by the city's housing needs; however, the Okui's South Thirteenth Street acreage remains dynamic and has been continually productive since 1944. (Courtesy *Times-Press-Recorder*.)

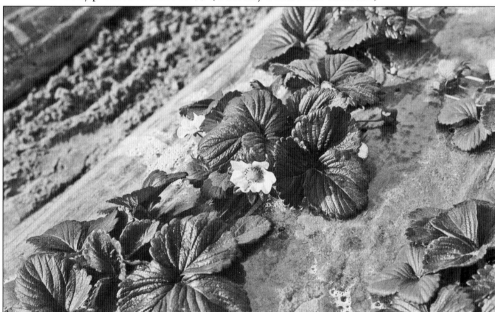

This 1970 photograph is of strawberry plants. Grover had the perfect conditions for growing the fruit. When North Fourth Street was dedicated and the road linked to Highway 101, transportation of the berries was easier. It wasn't until later that the produce from the area connected with the Pismo Oceano Vegetable Exchange (POVE) and its mechanized benefits to transport the produce all over the country, and thus 18-wheelers made their way into the POVE area in order to facilitate delivering what this area produced. (Courtesy *Times-Press-Recorder*.)

East of Grover was the area of Arroyo Grande, as shown in the 1970s photograph above. Grover's two and a half square miles were landlocked. Pismo was located to the north, but Grover's residents only had Highway 1 to travel in order to get there until Pismo Road/North Fourth Street was connected to Highway 101. The Arroyo Grande's valley knocked on Grover's door and added to Grover's agricultural flavor. The 1970 photograph below is Oceano, south of Grover. The photograph captured the equipment's path as it moved across the Arroyo Grande valley floor. Even though Grover was landlocked by Arroyo Grande and Oceano, most felt it was a privilege to have farmland around the area. (Both courtesy *Times-Press-Recorder*.)

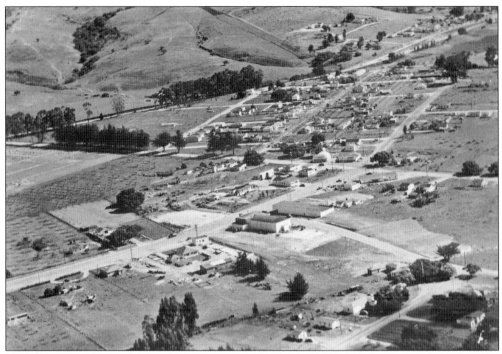

In this 1950s photograph, Grand Avenue traveled through the Oak Park area, the Fair Oaks division, and into Arroyo Grande until it reached El Camino Highway. North Eighteenth Street to the east was full of cows and brush, and the sand road stopped at the hill's top. Travel west beyond the tracks was on a single-lane sand road, which led to the ocean; the slough was on either side and vehicles had to be careful. (Courtesy Robert J. Garing Archives.)

This 1970s photograph is of north Grover. The area was filled with manzanita, sage, and brush. The hills in the background are Pismo, and the buildings were the Safeway, the Sears, a variety store, and the pharmacy, plus Hacienda Del Pismo Mobile Home Estates. White posts with cross members warned passersby to not go any further as the property dropped down immediately. (Author's collection.)

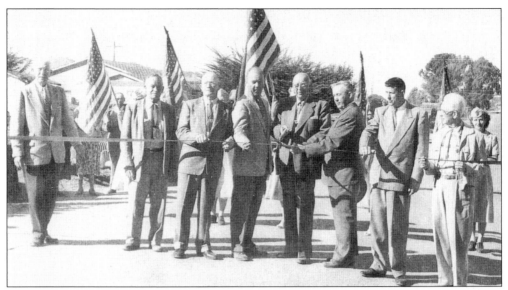

The dedication of North Fourth Street, photographed on October 13, 1957, meant Grover would no longer be landlocked. Using state money, Grover would be connected from Ocean View Avenue down to Highway 101. It meant buses, tourists, and transportation alternatives, and a means to enter Grover other than using Highway 1. (Courtesy Jean Hubbard.)

The Pismo hills seemed dream-like in this 1970 photograph. The only ways to travel to the Pismo hills were if a person knew the one road, had four hoofs, or was part of a cattle drive. There were no buildings in the area. (Author's collection.)

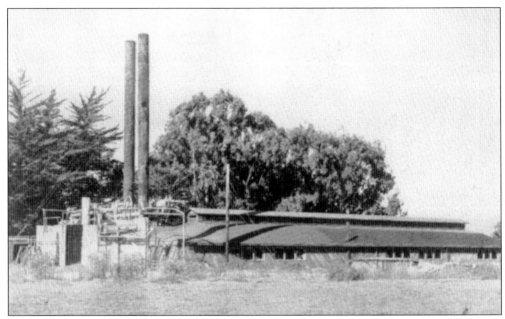

This 1951 photograph shows the Grover Cannery. In 1954, Pauley Process, Inc., processed foods for the Midway Packing Corporation. Lloyd Qualls help build the plant. Elton V. Tognazzini headed Pauley Process, Inc. In 1955, the cannery processed 3 million pounds of tuna. The product left by sea and Highway 1. The plant was on Pismo Road on the southwest side. In 1959, the cannery closed, and Baxter Lumber moved in. (Courtesy Jean Hubbard.)

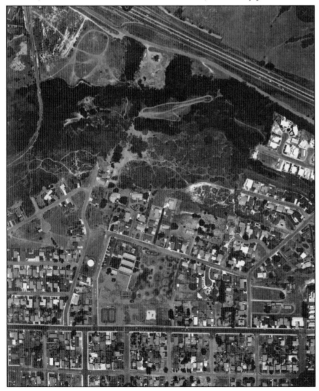

This 1976 photograph shows the Bagwell Ranch. North Twelfth Street initially stopped at Ramona Avenue. A bridge had to be constructed before El Camino Highway, as the estuary and Meadow Creek flowed parallel to El Camino Highway until it reached North Fourth Street, which had the estuary on both sides. (Courtesy Anita Shower.)

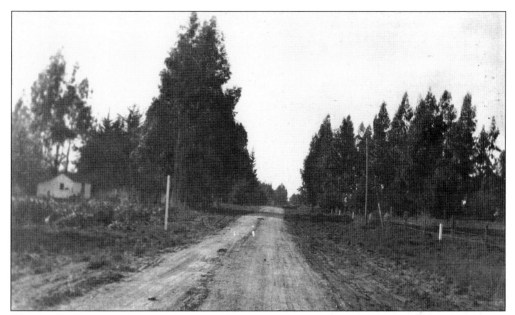

This 1940s photograph shows El Camino Highway before Highway 101 existed. The white house on the left was razed years ago. The remaining land became the congested frontage road to the south of Grover. Grover residents could only get to this area by using Highway 1; Pismo Road ended at the top of the hill at Oceanview Avenue. (Courtesy Howard Mankins.)

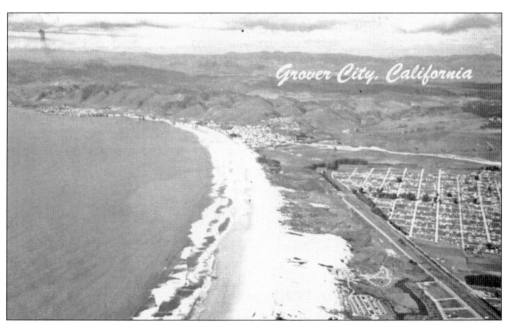

This 1950s photograph of Grover shows that the only scenery west of the railroad tracks is Highway 1, a road to the dunes, and the ocean. The State of California owned the beach area, and the citizens of Grover and tourists from everywhere enjoyed it. (Courtesy Wally and Jeri Lewis.)

This 1980s photograph of South Eighteenth Street (South Oak Park Boulevard) shows the great trees still standing. South Oak Park Boulevard was the dividing line between Arroyo Grande and Grover. East of the buildings on the left were strawberry fields; the acreage fronted Grand Avenue. Grover had strawberry fields behind the buildings on the right. (Author's collection.)

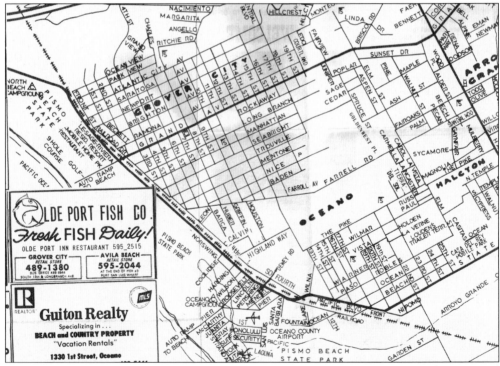

Grover's boundaries remained landlocked, as shown in this 1970 map. Arroyo Grande continued to spread, except for its west side, which was Grover's eastern border. Oceano remained unchanged. Grover's western boundary was the Pismo Beach State Park and the Pacific Ocean, and its northern boundary was Pismo Beach with Highway 101 running parallel. (Author's collection.)

Eight

MAPS, IMAGES, AND COLORFUL CHARACTERS

This map was the backside of an October 20, 1964, notice of a $980,000 sewer bond election mailed to the voters of Grover City. The first time the city proposed this, the voters defeated it by six votes. This notice highlighted Grover's population; however, the numbers were incorrect because, in 1974, the population was 4,800, nowhere near the proclaimed 7,000. In 1964, the city had only private septic tanks, cesspools, and outhouses. The benefits of passing the measure were better health, higher property values, elimination of costly septic maintenance, and elimination of water contamination. There was a construction plan, a finance plan, bond and federal grant information, and the cost to the taxpayer. All registered voters were urged to vote for this joint sewer project with the sanitation district. (Courtesy Jean Hubbard.)

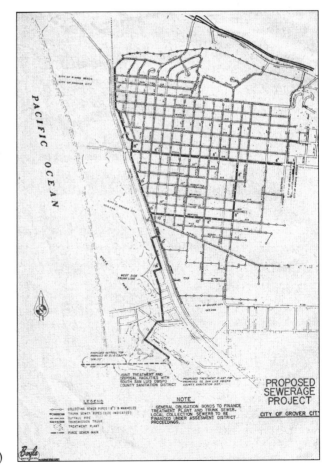

81

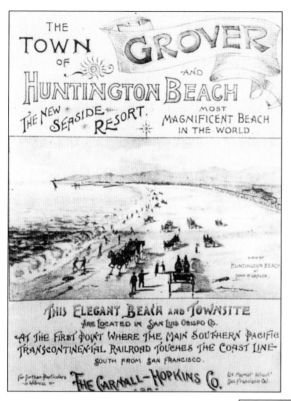

This advertisement, from the late 1880s, touts, "The Town of Grover and Huntington Beach . . . [as] the new seaside resort . . . [and] the most magnificent beach in the world." Dwight William Grover banked on the railroad coming to Grover and envisioned carriages on the beach. The locals remembered the beach traffic was at Pismo's end; Grover's area was tall with brush. (Courtesy Jean Hubbard.)

This 1930 image identifies Oak Park as a settlement of fruit farmers 3 miles from Grover. Pismo was on the shore road, and Port Harford was described as a principal shipping point of the south. Newsom Springs, the Tar Springs mine, Corral de Piedra Circle (Beckett's subdivision), Oceano, and Grover are also depicted. (Courtesy Jean Hubbard.)

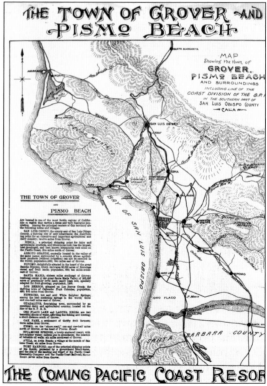

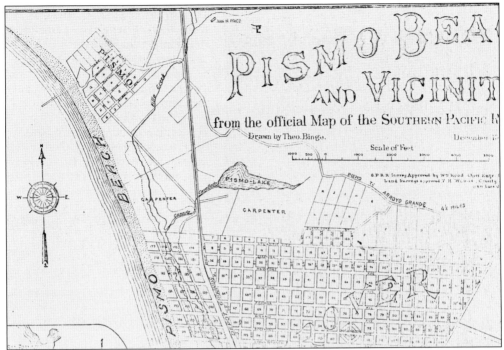

The Southern Pacific Railroad had an official map of each of the areas it served. This is a portion of the Pismo Beach and vicinity map from the 1900s. The northern section of Grover was known as the Carpenter area. Pismo was very small. The subdivisions in Arroyo Grande were named. Atlantic City Avenue was a named street in Grover. (Courtesy Jean Hubbard.)

THROW THE RASCALS OUT OF GROVER CITY HALL

Honorable mayor races during the 1950s were events where groups would announce a candidate. Voters would place a penny in strategically located cans around the city. Each penny was worth one vote. The person with the most pennies won. The winner donated his funds to his favorite cause, as did the other contestants to a choice of charity or community project. When these great times were taken over by notorious races that were rowdy and heated, the ire of some citizens funded campaign stickers. The one pictured above is from a 1980s campaign. (Author's collection.)

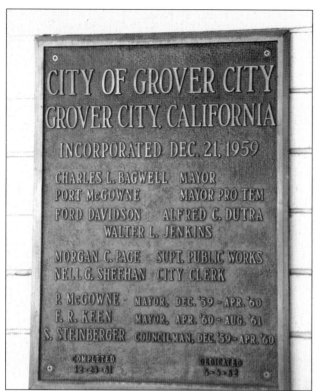

When the first Grover City Hall building on South Eighth Street was completed, a plaque was dedicated on June 5, 1962, and placed on a wall in honor of the city's 1959 incorporation. The name of the first mayor, the names of city council members, and the names of the superintendent of public works and the city clerk were written on the plaque. (Author's collection.)

The Grover City Development Company envisioned a water district so that the area would no longer rely on San Luis Obispo County for its water supply. When the Grover City Company Water District was completed in December 1961, pictured here, it opened the doors to prosperity. The district president was Zenas Bakeman; its directors were Ford Davidson, R. A. Tennant, R. L. Harder, and R. A. Hatley. (Author's collection.)

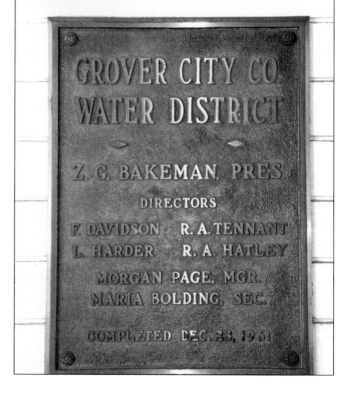

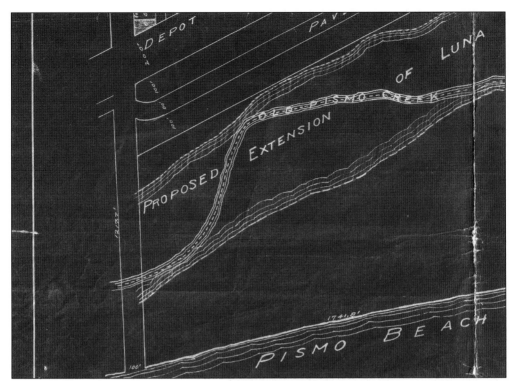

Pismo Pacific Properties played a role in the development of Grover. The company's articles of incorporation were filed with the State of California in 1931. The company's purpose was "to buy, sell, deal in, lease, hold or improve real estate." This is a partial plat map, dated 1930, of Grover's south side. The map is in near-perfect condition for being more than 76 years old. (Courtesy Linda Guiton Austin.)

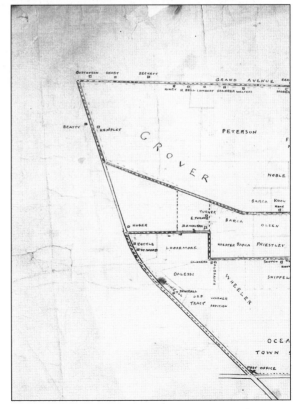

This 1903 map is based upon the position of the Oceano Post Office. The names at strategic points within Grover's boundaries gave an indication of who owned the land at that time. Bartolomeo Barca arrived in Grover in 1903 and purchased land adjacent to acreage on Farroll Road. Part of the Barca land veered into privately owned Farroll Road acreage. (Author's collection.)

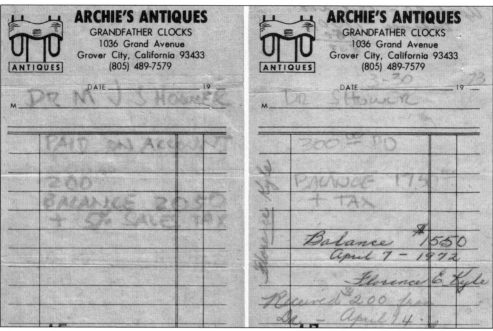

Grover had an antique store, Archie's Antiques, which sold grandfather clocks. These receipts are from the store, which was located at 1036 Grand Avenue. The clocks were expensive. One, with the hallway and stairs beautifully carved into the plate at the bottom of the clock, supposedly was the view the carver had when he was commissioned to complete the artwork. (Author's collection.)

The business Mr. Glenn House of Ladies Fashions was in a house that belonged to James Harner's mother. Cynthia Glenn wanted the house. Mrs. Harner had the house disassembled in Bakersfield and moved to Grover's Grand Avenue in the mid-1950s. When Corwin Glenn asked Cynthia why she wanted the old house, Cynthia replied, "Because I can sew, and I can do anything." Cynthia wanted a dress shop. (Author's collection.)

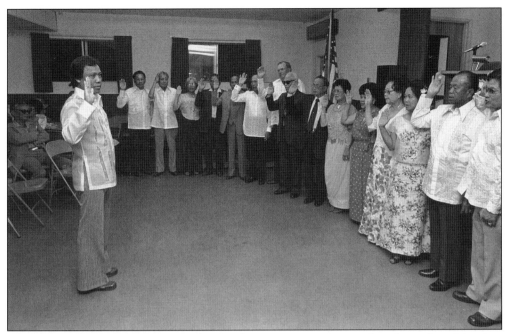

The Filipino Community Center was known for its community outreach and grand participation, especially during the swearing in of its board each new year. This photograph is from a ceremony in 1984 inside the center located on South Thirteenth Street. (Courtesy *Times-Press-Recorder.*)

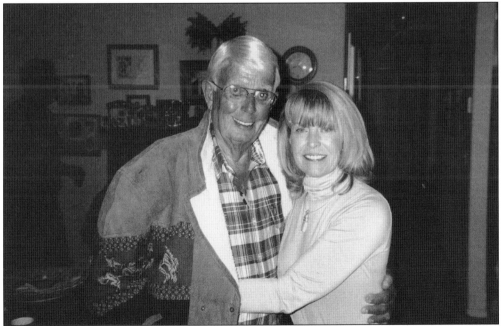

John and Barbara Nichols, shown here in a *c.* 1990 photograph, were a part of Grover. They visited Pismo Beach often. In 1964, when they heard that Pal's in Pismo was for sale, they purchased it and renamed it The Outrigger. John attended bartending school and janitorial school, as he was not an expert at either. He was a great contributor to Grover with his businesses and visions for future growth of the area. (Courtesy Scott Nichols.)

In the late 1970s, Grover hosted the All States Picnic where Mid-State Bank and Trust is today. When that event ceased, the Grover City Grange began to put together a Fourth of July picnic at the Sixteenth Street Park. On the left in this c. 1980 photograph is Leona Hero, the matriarch of the Grover City Grange, during one of her last Grange Fourth of July Picnics. (Author's collection.)

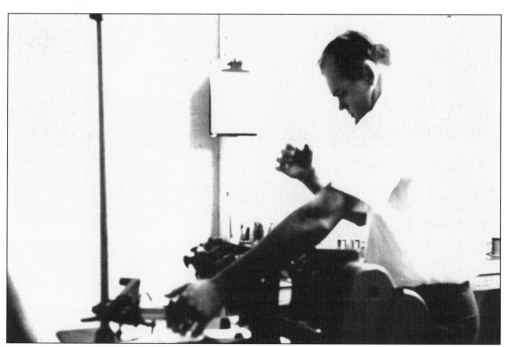

Mike Greeneish, pictured here in the 1960s, founded California Fine Wire with a homemade wire-drawing machine. The business included a contract with Sandia, a California research facility that worked with military and nuclear technology. Greeneish's wire applications ranged from microchips and catheters to space probes. Word had it that wire from California Fine Wire could be found in the hair pieces for Barbie Dolls. (Courtesy *Times-Press-Recorder*.)

When John Wysong arrived in Grover he was 23 years old. He was a meat cutter with Safeway. Wysong set a goal to work in every Safeway store from Paso Robles to Ventura. He stayed with Safeway when it became Williams Brothers. Wysong even remembers when Williams Brothers purchased Young's Giant Foods. This is his class of 1951 photograph. (Courtesy John Wysong.)

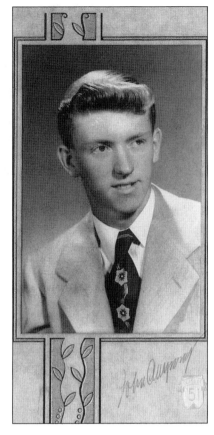

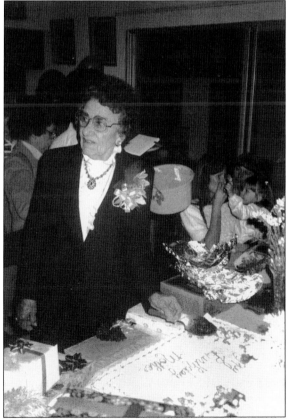

Rose Machado was born in rural Arroyo Grande in 1910. During the 1970s, Machado and her daughter and son-in-law moved to Grover City Heights in the home known as the Brooks's House. Machado lived in Grover until 1989. Her son Eugene remained in charge of the Machado's rural Arroyo Grande properties. This 1980 photograph is Machado at a birthday party. (Courtesy Mildred Handy.)

Dr. Robert Burns, photographed here in 1954, and Betty Burns moved to Grover in early 1965. Dr. Burns was the Grover area's first full-time podiatrist. The Burns's sons are Lawrence, a senior staff systems engineer for General Dynamics Systems in New Mexico; Gregory, a senior field engineer for Honeywell in New Mexico; and Robert, an engineering geologist for the California Department of Water Resources. (Courtesy Betty Burns.)

Dr. Manferd Shower, photographed here in 1968, arrived in the Grover area in 1968 to assist another orthodontist in Arroyo Grande. Dr. Shower purchased the existing part-time practice, added it to his other four orthodontic practices between Carmel and Paso Robles, and became this area's first full-time, exclusive orthodontist. He settled in north Grover in 1970. His trademark was a 1957 Willy's Jeep. (Author's collection.)

Nine

BUSINESS, AGRICULTURE, AND RECREATION

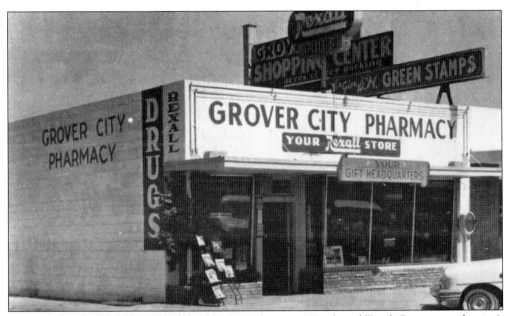

Grover started to bloom in 1959. The downtown between Ninth and Tenth Streets was the city's hub in the 1950s and 1960s. In order to devote their time and energy to the Pocketbook Market, Braxton and Pauline Swack sold the U-Save Market to the Barrs. When the Barrs purchased the market, it expanded into the back parking lot. A small café rented space west of the feed store. This is a photograph of the Grover City Pharmacy on the corner of Ninth Street and Grand Avenue; the post office was part of this block. The strawberry fields within Grover were still evident in 1960. Hero's pig farm continued to thrive. Tourists came to enjoy the beach and walk and shop along Grand Avenue. The south side of Grand Avenue had small stores, including a Western Auto. The downtown had diagonal parking. In 1971, the city council authorized the renaming of Pismo Road to North Fourth Street. (Author's collection.)

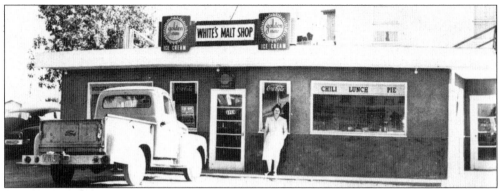

White's Malt Shop opened at the corner of Fifth Street and Grand Avenue on the south side of the street. The building saw many tenants from its origin as the malt shop, including Bills Tackle, Too and a rent-a-car company. White's Malt Shop, photographed here in 1956, featured chili, pie, and Golden State ice cream. (Author's collection.)

In 1956, the Grover City Shoe Shop's proprietor was W. H. Ray. "For the Good of Your Sole See Me" was stenciled over the top of his doorway. The business at 861 Grand Avenue stayed for quite awhile. The South County Sanitary Service moved into the shoe shop's space. (Author's collection.)

In this 1957 photograph, the Grover City Cleaners was located on Grand Avenue. The cleaners did cleaning, pressing, dyeing, alterations, and repairs. The store offered free pick-up and delivery. It was the era of trading stamps, so the business added "Your United Trading Stamp Redemption Center" to the list of available services. (Author's collection.)

Faye Keen was a member of the all-volunteer fire department. Keen's complete real estate and insurance service business opened in 1950 on the corner of Eighth Street and Grand Avenue in a Quonset hut. When the fire department was first organized, it did not have a building, and the equipment was parked on Keen's Eighth Street corner. (Author's collection.)

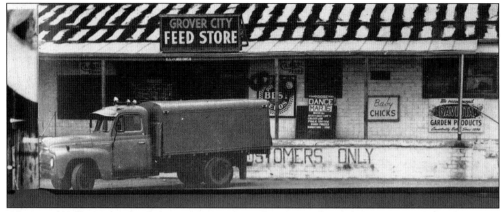

Alton and Sally Lee opened the Grover City Feed Store in the early 1950s at Tenth Street and Grand Avenue. The Lees belonged to the Grover City Grange. The feed store was the supplier of garden supplies, chicks, seeds, and fertilizer. The store posted important signs, including Pismo Beach Moose's announcements about their dances. (Author's collection.)

A&W Root Beer was located at Eighteenth Street and Grand Avenue. It offered drive-up service with an array of food and beverages. Behind it were acres of brush and strawberry fields. The Arroyo Grande city limits sign had a tendency to fluctuate along the Grand Avenue side of A&W's property, depending on yearly surveys. (Author's collection.)

The Grover City Development Company, photographed here in 1953, moved in the early 1950s to this area between Second and Third Streets on Grand Avenue. Charles Bagwell's father, Horace, began the business. The entire shopping center was remodeled during the late 1980s. The development company moved into a separate building at the west corner of Second Street at Grand Avenue. (Author's collection.)

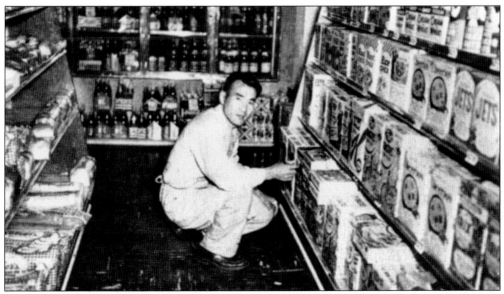

Nishi's Market, photographed here in 1956, was on the south side of Grand Avenue at Eleventh Street. The store carried food items and soft drinks and was one of several small, individual grocery stores that lined Grand Avenue. Most businesses populated Grand Avenue between Eighth and Tenth Streets. (Author's collection.)

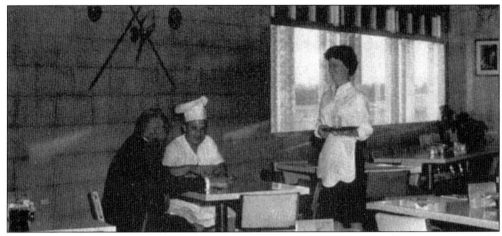

This restaurant was well known, and from this early 1950s photograph, it seemed simple. Lou's Italian Restaurant served great food. Behind the restaurant were several buildings that were blue, two-story apartments. The restaurant building and apartments were razed to build a Smyth's grocery store in the late 1980s. In the 1940s, this was the location of a huge turkey farm. (Author's collection.)

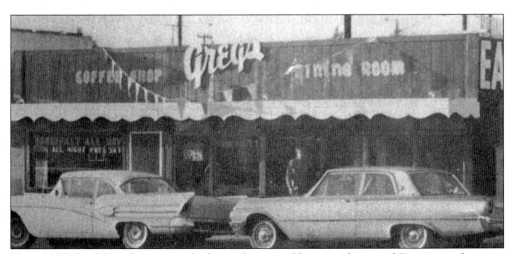

The 900 block of Grand Avenue, which was the central business district of Grover, was home to many small businesses. Greg's Restaurant, shown here in the mid-1950s, leased the space known as 967 Grand Avenue and had a coffee shop as well as a dining room. (Author's collection.)

The acreage across from the Hero's Pig Farm, pictured here in the 1970s, was a grazing area for cattle. The property belonged to the Hero family. It was a great source of pride to the community to have agriculture and horses living side by side with apartments and homes. Farroll Road was known for this view of rural life. (Author's collection.)

Hero's Pig Farm seemed to be the middle of Grover. In the left corner of this 1970s photograph, Einar Hero's house is visible. There was a barn to the left of the house and a large stand of trees. Hero's son, also named Einar, placed a Christmas star on the house's roof each December; it was visible from the crest of north Grover. (Author's collection.)

Agriculture continued to flourish in and around Grover during the 1950s and 1960s. The fields were a welcomed sight but were eventually replaced by houses. This 1970 photograph shows the area facing the Cienaga District, which was past Grover's southern border on the way to the Oceano Dunes. (Author's collection.)

Grover became known as one of the Five Cities communities consisting of Arroyo Grande, Grover City, Pismo Beach, Oceano, and Shell Beach. Tourists came to look at the ocean and play at the beach. This 1970 photograph is a view from a Pismo Beach location looking out to the Pacific Ocean's horizon from a walkway and gazebo. (Author's collection.)

Recreation during the 1960s took various forms. It was common practice to find horses to ride along the beach, as shown here in 1970. It was also common to find horses grazing in yards in the Grover City Heights subdivision in 1970; the horses wandered from the El Camino Highway area where there were pastures. The grass in the subdivision appealed to the horses. (Author's collection.)

Clamming along the shore was a great source of recreation and entertainment. Along with the clam fork, the other necessities were a bucket and a measuring device. If the clam did not measure up, it had to be put out to sea. This was a family activity and also brought tourists to the area. (Author's collection.)

Surfers could be found at the beach. The Five Cities area, which included Grover, had a surfing area. For those lucky enough to live at the Sunset Terrace Apartments in Grover, this swimming pool was better than the ocean but not large enough for surfing. (Author's collection.)

Everyone enjoyed Memorial Day at the beach. It was a sight to see the array of vehicles. It was common to see an army tank or a vehicle with high suspension with a difficult approach. What began as hundreds of vehicles on the beach, including used buses, became thousands who descended upon the area. (Author's collection.)

Summertime included going to the beach, barbequing, and participating in a parade. In addition to the beach parade for Memorial and Labor Days, neighboring Arroyo Grande always had parades. This early 1970s photograph is from Arroyo Grande's Harvest Festival Parade. The Harvest Festival Parades always showed off vintage vehicles. (Author's collection.)

The area was fortunate to have Santa and Mrs. Claus visit each December. This 1980 photograph of Mr. and Mrs. Claus was taken during a Grover City Grange Christmas Party. Mr. and Mrs. A. K. (Pete) Dougall charmed the area as the traditional holiday couple beginning in the 1970s. (Courtesy Elsie Greenmyer.)

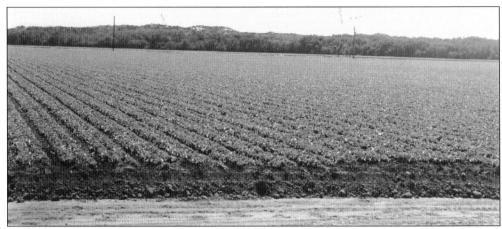

Around Grover, it was customary to build a house at the back of a lot. Parcels adjoining the homes were profitable truck farms, photographed here in 1970. Truck farms were so called because a small truck was needed to haul the harvested crops to market. The farms provided both a sense of worth and recreation. (Author's collection.)

From the flea market concept, the garage sale idea was born and thrived. Grover always had its share of weekend garage and yard sales. It was easy to leave with loads of books, household items, exercise equipment, and tools. Grover town officials decided to enact an ordinance regulating the placement of garage sale signs; it did not go over well. (Author's collection.)

Foster Freeze led the way in the 1950s with fast food. Burger King followed in the 1980s at the corner of Oak Park Boulevard at Grand Avenue, Grover's eastern boundary. The franchise provided fast food, a clean environment, and a workforce. Previously, the site was home to a radiator shop and before that children would secure their horses in the lot and walk to the beach. (Author's collection.)

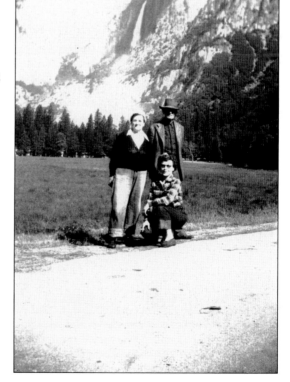

Living in Grover provided residents with recreation from the seashore to the Pismo Pier and to the Oceano Dunes. However, once in a while, people enjoyed traveling from Grover to the higher elevations. This 1948 photograph of Roberta (Bertie) Smith with her parents shows the backdrop of Northern California. (Author's collection.)

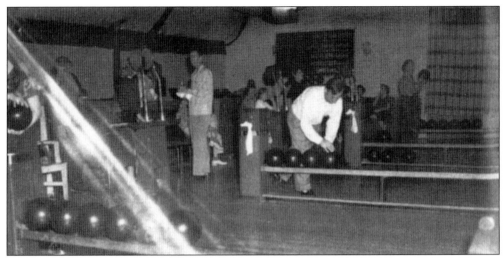

Grover did not have a bowling alley, although the idea did come before the city council during the 1970s. Pismo Bowl, shown here in 1953, provided all the essentials necessary to bowl and to enjoy a form of recreation that was both fun and competitive. The center was located in downtown Pismo Beach and was a local tourist attraction. (Author's collection.)

In the late 1960s and early 1970s, the hills of Pismo Beach were relatively pristine. To the left in this 1970s photograph is the famous Pismo Pier. It is a source of recreation because it provides a place to visit, to walk, to socialize, to fish, and to use as a painting backdrop. (Author's collection.)

Ten

GROVER CITY BECOMES GROVER BEACH AND THE TRAIN ARRIVES

The first person to proclaim it was time for Grover City to change its name was Master James L. Dykes during a 1954 Grover City Grange meeting and immediately after Master Dykes was proclaimed the new honorary mayor of the city. Dykes was the Grange's candidate in the race and was pushed down Grand Avenue in a wheelbarrow by the two defeated opponents, Mrs. Ruby Sullivan and Mrs. Lena Stevens. Dykes felt it was time to change the city's name and proclaimed it would be his first order of business. He touted that the name should be changed to either Grover City Beach or Grover Beach. Naturally, the honorary mayor did not have an order of business. Dykes's thank you announcement declared, "I shall do my best for civic unity so that Grover City may continue to progress." In 1992, the issue surfaced again, but this time it came to a vote of the people; Grover City became Grover Beach. This photograph was taken in 1970. (Author's collection.)

It was not easy to change the name of a city, especially its signs. Caltrans had to be alerted that an election resulted in the citizens of Grover City voting for a change in the city's name to Grover Beach. The Highway 101 sign had to reflect the change. This 1996 photograph shows the sign on Highway 101 traveling from the south along the highway. (Author's collection.)

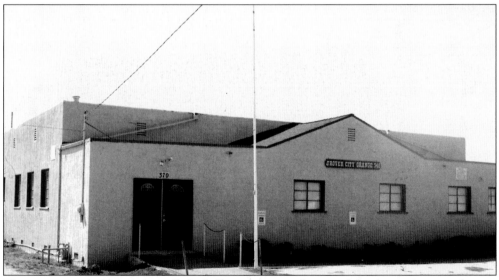

There were two holdouts when all the ballots were in and counted for the city's name change. The Grover City Pharmacy continued to answer the telephone, "Grover City Pharmacy," and the Grover City Grange kept its name. The Grange was chartered as the Grover City Grange, and the charter was the registered name. In this 1996 photograph, the Grange Hall remains nearly the same as the day it was built. (Author's collection.)

Along Highway 1, there was a city marker on the east side toward Grand Avenue that had to be changed from Grover City to Grover Beach. When the votes were in and counted, the new name won by 96 votes according to a newspaper account. Supposedly, the proponents were as happy as clams. (Author's collection.)

The chamber of commerce was a necessity in promoting business. The chamber was organized in the 1950s under the name of the Grover Civic Association. This building, photographed here in 1980, was the chamber's office until the office was moved to the Grover Beach Train Station complex after the train depot was built in 1996. (Author's collection.)

The idea of completing Pismo Road culminated in a barbershop on Grand Avenue. In the summer of 1955 in Johnston's barbershop, Zenas Bakeman, Herbert Johnston, and James Dykes met and placed their names on a bond for $1,000 toward securing a measure to have North Fourth Street connected with Highway 101. The connection was dedicated on October 6, 1957. The dedication committee included supervisor Sheehy, honorary mayor H. V. Bagwell, county road commissioner Kenneth Beck, planning director Melvin Bakeman, members of the press, representatives of the state public utilities commission and state division of highways, a representative of the Grover City Civic Association, and a representative from the Western Greyhound Bus Lines. Jack Dineen from the civic association's transportation committee was in charge of the program. When the city's name changed in 1992, the city marker and the city's name sign on North Fourth Street, seen here, were changed to reflect the new Grover Beach. (Author's collection.)

Grover's first post office was in Baker's grocery store on Grand Avenue. According to Lloyd Qualls, his wife Juanita and Mrs. Baker called the government to request a post office for the area. When they said the name of the community was Grover, they were told that there was already a Grover, California. The government suggested that the area be called Grover City. To secure post office box service for the new Grover City Post Office, a required number of signatures had to be collected. Juanita Qualls and Mrs. Baker walked around Grover, Oceano, Pismo Beach, and Arroyo Grande to have everyone sign up in order to meet the requirement. The post office, shown here in 1996, opened on Grand Avenue in 1948. (Author's collection.)

When the citizens voted in 1992 to change the name of the city from Grover City to Grover Beach, city hall emphasized it would not be financially responsible for the changes to existing signage. Citizens gave their financial support for the change. This is a marker at the eastern boundary of Grover Beach, shown in 1996, located on Grand Avenue at Oak Park Boulevard. The new markers pictured the blue wave of the ocean and the words "Welcome to Grover Beach" and were placed at the designated, high-traffic areas of the city's boundaries. Landscaping was part of the plan. This marker constructed on a corner in front of a grocery store parking lot was the previous site of Lou's Italian Restaurant, several apartment complexes, and, many decades ago, Grover's largest turkey farm. (Author's collection.)

After the name of the city changed to Grover Beach in 1992, many businesses had to change their letterhead, envelopes, property signs, parking curb markers, and door entrances. Businesses also had to change their information in all of the appropriate publications, including registries, telephone books, zip code directories, national affiliations, credit reporting services, return address labels, and bank drafts and checks. The Grover City Door and Supply Company's proprietors were relatively new to the business and inherited a massive amount of stationery and supplies that still read as Grover City. The owners simply changed their name, as shown here in 1996, to reflect the city's new identity. (Author's collection.)

This motel was the first motor lodge in Grover. It dates back to the 1950s when it was known as the Lone Pine Motel and had front-door, head-in parking. It became the Grover City Motel and always had an array of tenants, both short- and long-term. It was centrally located near a service station and was within walking distance of a bank, a hardware store, and the post office. It was reported that former city council member Charles Comstock once owned the Grover City Motel. When Grover was finally granted adequate bus service, there was a bus bench right outside the motel on its Grand Avenue side. The motel changed its name to the Grover Beach Motel when the city changed its name. (Author's collection.)

Changing the city's name to Grover Beach had an impact on the community. The proponents proclaimed it would bring tourism to Grover. What they did not realize was the financial impact it would have on businesses, individuals, signs, maps, directories, and schools. The Grover City Elementary School changed its name to the Grover Beach Elementary School, photographed here in 1992. The school had several meetings regarding changing its name but finally decided to make the change along with the rest of the community. There were other schools in the area, but this particular elementary school was the only one whose official school name began with "Grover City." This one was also the first elementary school in the area. (Author's collection.)

Grover had an all-volunteer fire department for many years. Lloyd Qualls was the first all-volunteer fire captain. The original station was built on land donated by the county board of supervisors. It was on Ramona Avenue at North Ninth Street. The city hall first opened and conducted business in the fire station on Ramona. When the city hall moved to South Eighth Street, the fire station stayed in place. Eventually, the fire station moved to 701 Rockaway Avenue, where a new station was designed and constructed. Before moving into these quarters, the fire station was around the corner on the South Seventh Street side of Rockaway Avenue. The fire station in this photograph changed its name to the Grover Beach Fire Station. (Author's collection.)

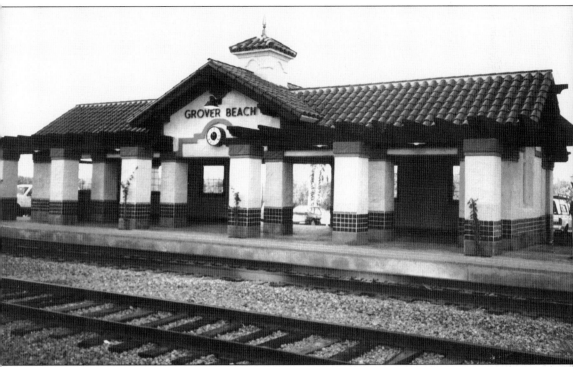

During Dwight William Grover's era, the Southern Pacific Railroad traveled through California from the north and ended at San Miguel in San Luis Obispo County. Grover, counting on the railroad coming to the city of Grover, purchased the land from John Price. Grover thought the area next to the ocean would make a wonderful seaside community. He wanted to entice Collis P. Huntington of railroad fame to bring the train to his new town. Grover thought naming the beach after Huntington would help, but the effort failed. This photograph is of the train station on November 2, 1996. The Amtrak San Diegan was a part of the train parade; the 1996 Olympic train car was in the rear. (Courtesy Pam Spicer.)

Citizens were delighted with the plan for the entrance to Grover Beach, photographed here on November 2, 1996. A marker was designed and installed, along with new plants and borders. Years before, the citizens voted to change the city's name from Grover City to Grover Beach, as noted on the Highway 1 at Grand Avenue marker. The 1984 U.S. Olympic Committee donated the flagpole to Grover. The flagpole was originally at the Grand Avenue and Highway 1 park entrance but was moved closer to the depot for the festivities and its final placement. The park, adjacent to traffic, was a focal point and had a great impact for those traveling from Grover's beach, Pismo Beach, or Oceano. It was imperative that the western entrance to the city match the other city entrances. (Courtesy Pam Spicer.)

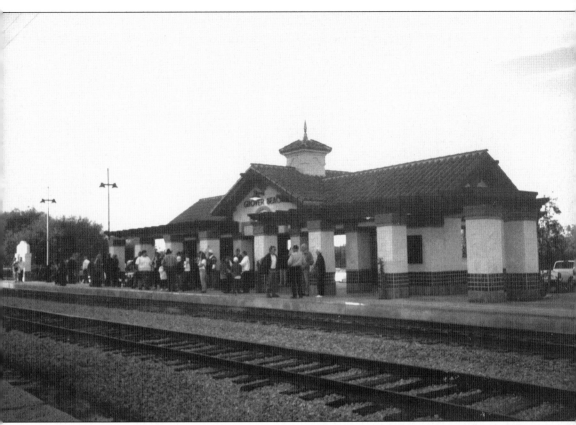

In this November 2, 1996, photograph, the back of the Grover Beach Train Station is visible. The community came out to welcome the arrival of Amtrak's San Diegan train. The train depot captured an early California–style theme. With Amtrak's arrival, the city finally had a tie to the railroad; everyone welcomed the $1.6 million facility. It was an effort between Caltrans, Amtrak, and the City of Grover Beach with funding from State Transit Capital Improvement and Proposition 116 bonds. RMO Architects of Grover Beach provided the design work, and the construction bid was awarded to the IBEX Construction Company of San Diego, California. The station's proximity to local government offices and the public beach made it a valuable commodity for the City of Grover Beach, residents, tourists, and businesses. (Courtesy Pam Spicer.)

It took from 1887 until 1996 for the train to become a reality in Grover. This November 2, 1996, photograph is of the Grover Beach's city council, including Mayor Ronald Arnoldsen and council members Lowell Forister, Marcia Hamilton, Henry E. Gene Gates, Fred Munroe, and others during the festivities welcoming Amtrak to the Grover Beach Station. The station's official name was the Multi-Modal Transportation Facility, and it was designed by RMO Architects and engineered by Dyer Engineering. Anthony Orefice of RMO Architects was the principal architect and the project manager for the design phase of the project. The City of Grover Beach City Council turned the first shovels of dirt in May 1996. (Courtesy Pam Spicer.)

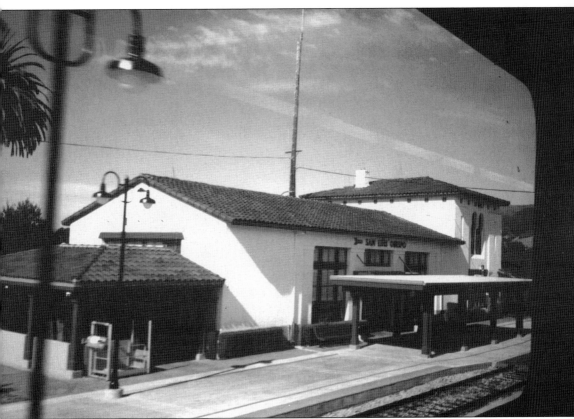

This is an inside view from Amtrak's San Diegan looking out toward the early California–style depot. The train stopped in an area it customarily breezed by. Passengers now had the opportunity to travel from the Central Coast to a southern destination or take passengers on its northern route to San Luis Obispo. Everything inside the train was perfect; even the conductor made his rounds. As the train rolled along, the countryside and the breathtaking views of the Central Coast became more and more endearing. Further landscaping was recommended and would be an additional sight once the train made that long, straight drive as it headed into the Grover Beach Train Station. (Courtesy Pam Spicer.)

This November 2, 1996, photograph is of the lighted engine as it began its straight roll into the Grover Beach Train Station. The feel of the locomotive as it rolled in was a feeling long remembered by the more than 1,000 people who witnessed it making history. The train could be heard as it broke through the paper welcoming banner, making it a part of the city's transportation, commerce, businesses, and tourism. Amtrak's train and bus service were now a part of Grover Beach. (Courtesy Pam Spicer.)

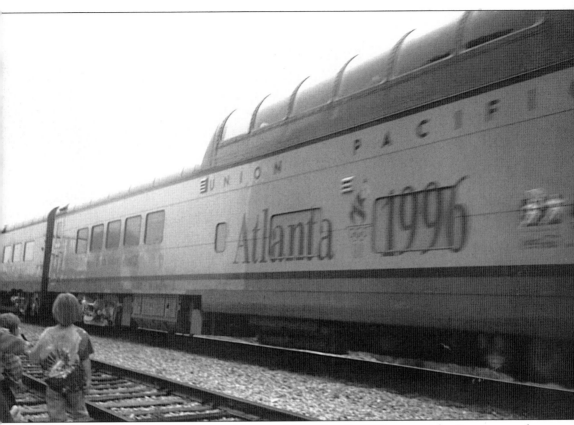

The 1996 Olympic train car, pictured here on November 2, 1996, was a sight. It was part of Amtrak's San Diegan that stopped for the first time at the Grover Beach station. The crowd numbered more than 1,000 people. Many entities had to work together to make this spectacular presentation of the lighting of the Olympic torch to the cauldron on the Olympic car. The Olympic car was green, gold, and red and had "1996 Olympic Torch Relay" stenciled on both sides and on the end. The 1984 U.S. Olympic Committee gave the City of Grover City the flagpole that was a part of the 1996 Multi-Modal Transportation Facility. (Courtesy Pam Spicer.)

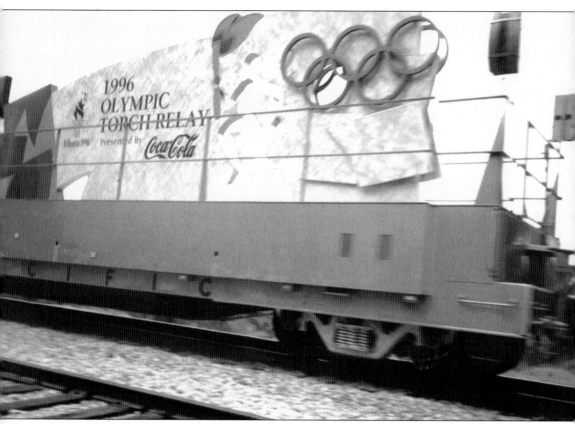

A portion of the train photographed on November 2, 1996, included the 1996 Olympic cars. This particular car was sponsored by Coca-Cola and made for an impressive sight as the train rolled into the Grover Beach Train Station. Olympic sponsors were financial supporters of the 1996 Olympic Games to be held in Atlanta, Georgia. Coca-Cola paid $12 million for the right to sponsor the torch as it crossed America on the 84-day, 15,000-mile journey with 10,000 runners. This particular Olympic car was designed to depict the five-ring Olympic symbol and a silhouette of an Olympic runner with the Olympic torch. Dignitaries, children, and adults attended the event. (Courtesy Pam Spicer.)

The audience and participants were excited on November 2, 1996, to be a part of the completed circle from the inception of Grover and its founder's dream of the railroad to the reality of the Grover Beach Train Station. There was a profusion of people around the train station waiting for the 1996 Olympic torch-lighting ceremony. There were cameras and video equipment and cheering from the crowd. It was history in the making and the talk of Grover. The crowd included adults and children, both residents and visitors. Kimberly Maas of KSBY is on her way to pass the Olympic Torch flame to the cauldron at the top of the Olympic platform on the Olympic train car. (Courtesy Pam Spicer.)

This photographed youngster, Lance Henderson, is finally on a train. The San Diegan arrived at the Grover Beach station and offered rides from Grover Beach to San Luis Obispo and back. It was a dream come true for Henderson. The city council handed out train whistles instead of cigars in celebration. Usually the locals heard the train coming, and those on the Nipomo Mesa not only heard it but could also see it as it traveled either north or south. The inside of the train was beautiful, and the feeling of riding along the tracks was an experience Henderson would long remember. The train opened an array of travel possibilities for Grover Beach. (Courtesy Pam Spicer.)

A crowd gathered at the train station on November 2, 1996, to watch the 1996 Olympic torch-lighting ceremony. The gathering began early in the morning. As with most Olympic events, there was a great deal of planning and logistics involved in order to tie in this torch-lighting ceremony with the opening of the Grover Beach Train Station. The City of Grover Beach had to coordinate the endeavor with NBC and its local affiliate, KSBY in San Luis Obispo, California. (Courtesy Pam Spicer.)

Grover Beach mayor Ronald Arnoldsen addressed the crowd dressed in a costume from the 1880s era. He completed a remarkable performance both in his manifestation and his "State of the Train Station" address. Many dignitaries from the local communities and all parts of the state of California attended the ceremony in 1996. The station was designed by RMO Architects of Grover Beach. Anthony Orefice, the principal architect, received accolades from the elected officials. IBEX Construction Company built the facility and also received glowing remarks and applause. Anthony Busietta, the owner of IBEX Construction Company, was in attendance to represent the company. City officials alerted the crowd that Orefice promised working drawings in 13 weeks; it swayed Grover Beach to contract with RMO Architects. Orefice stayed true to his word. (Courtesy Pam Spicer.)

This is the NBC news truck that covered the ceremonies surrounding the new train station on November 2, 1996. Workers from the IBEX Construction Company rushed to complete the station the day before the grand opening and ribbon-cutting ceremony. Just days before the event, the weather caused concern because Grover Beach experienced its first storm of the season. But the storm did not deter Amtrak's No. 801 on route to San Francisco; on that particular Tuesday, it easily passed through Grover Beach. (Courtesy Pam Spicer.)

ACROSS AMERICA, PEOPLE ARE DISCOVERING
SOMETHING WONDERFUL. *THEIR HERITAGE.*

Arcadia Publishing is the leading local history publisher in the United States. With more than 4,000 titles in print and hundreds of new titles released every year, Arcadia has extensive specialized experience chronicling the history of communities and celebrating America's hidden stories, bringing to life the people, places, and events from the past. To discover the history of other communities across the nation, please visit:

www.arcadiapublishing.com

Customized search tools allow you to find regional history books about the town where you grew up, the cities where your friends and family live, the town where your parents met, or even that retirement spot you've been dreaming about.